IMAGES of America
THE MOOSEHEAD LAKE REGION

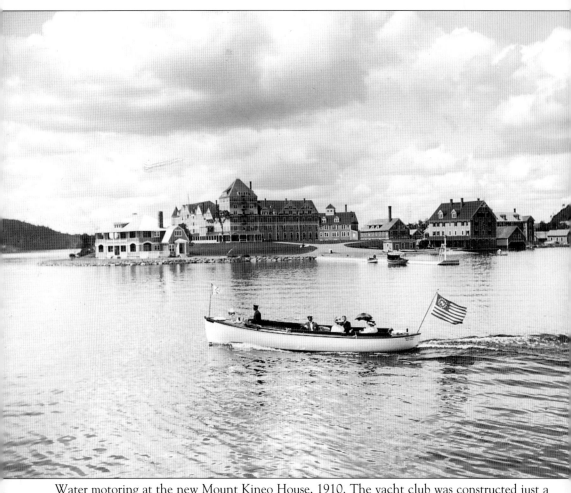

Water motoring at the new Mount Kineo House, 1910. The yacht club was constructed just a few years before the photograph. The boat is a Moosehead Lake Yacht Club launch frequently used between Kineo and Rockwood.

IMAGES
of America
THE
MOOSEHEAD LAKE
REGION

Nathan D. Hamilton and Cynthia A. Thayer

Copyright © 1995 by Nathan D. Hamilton and Cynthia A. Thayer
ISBN 978-0-7385-8847-6

Published by Arcadia Publishing
Charleston, South Carolina

Printed in the United States of America

For all general information contact Arcadia Publishing at:
Telephone 843-853-2070
Fax 843-853-0044
E-mail sales@arcadiapublishing.com
For customer service and orders:
Toll-Free 1-888-313-2665

Visit us on the Internet at www.arcadiapublishing.com

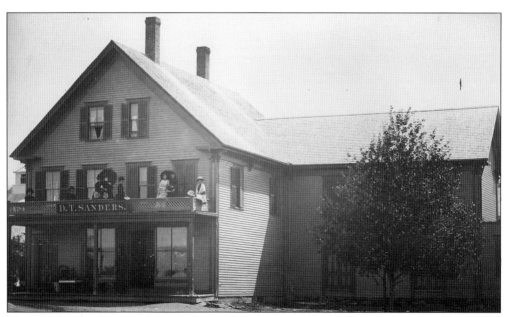

The D.T. Sanders Store and upstairs home, 1879. Family and friends are gathered on the upstairs porch. (H.A. Sanders Jr.)

Contents

Acknowledgments		6
Introduction		7
1.	The Foot of the Lake: Greenville and the Junction	9
2.	Places Around Moosehead Lake	35
3.	On the Lake: Canoe, Motorboat, and Steamboat	67
4.	The Center of the Lake: Mount Kineo and the Buildings	79
5.	On the Land: Horse and Carriage, Trains, and Cars	93
6.	Some of the People . . . Not All of the People	105

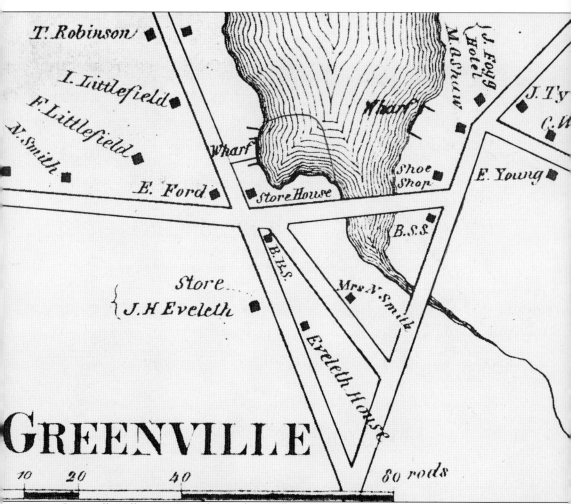

Greenville Village, 1858, as featured in *Wallings Map of Piscataquis*. To get a sense the expansion the Village, compare this map with the photograph of Greenville Village on p. 9 and Colby's map on p. 18.

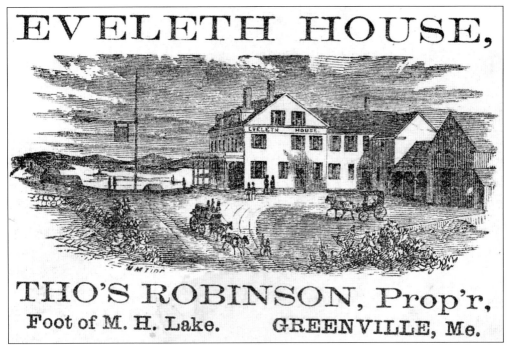

An Eveleth House business card, 1860s. "Tho's" Robinson was a steamboat captain and the father of Charles Robinson.

Introduction

In the nineteenth century, the Moosehead Lake region was opened by Euroamericans and transformed from a beautiful wilderness to a working frontier. The large white pine was laid down first and houses for lumbering, hunting, and farming soon established. The local Native Americans, as well as those from Indian Island, Tobique, and Saint Francis, were on good terms and often served as travel and sport guides. The scale of change increased with clear improvements in transportation, both on the land and on the lake. Larger volumes of timber were harvested and the profits were shared locally and down river to expand trade and commerce. The growth in the late nineteenth century was marked by expanded spruce and hardwood logging, more numerous, larger, and faster boats, and most importantly, the arrival of the railroad to the lake shore. At the center of all and an index of these changes were the growing hotel establishments on Mount Kineo. The significant growth in size and quality of accommodations combined with good transportation brought in many tourists from the 1880s to the 1920s.

The earliest images recorded are on daguerreotype photographs and stereoscopic view cards. Most American parlors featured stereo viewers and sets of cards in the 1860s and '70s. At least eight card-makers images capture the initial changes in the environment and way of life at Moosehead. The photographs brought together here capture some of the changes in the way of life and landscape from the mid-nineteenth century on to the mid-twentieth.

One
The Foot of the Lake: Greenville and the Junction

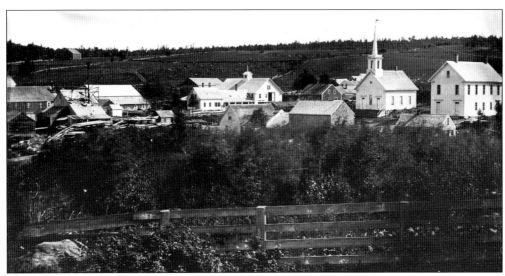

Greenville Village in 1860s. This photograph was made from an 1860s daguerreotype photograph passed down in the Sanders family. The building on the right with two front doors is the school. This building was later to become the town office. On the left is the original Union Church, the first to be erected in town in 1858; the steeple and belfry were completed in 1874, and Reverend Cameron supplied the first bell. Next to the church is a Cape-style house where Sanders Store now sits. The house belonged to Mr. Hildreth. The next structure in the center has a large barn, and was first the Charles W. Gower then the Milton G. Shaw residence. The house currently stands without the barn, and is located behind Shaw Public Library at the end of Pleasant Street. The next building on the east side of the street was occupied by the Caron Carriage shops of M.G. Shaw. The building complex on the west side of the street and at the left was first Gower's Mill and Store, and was later the Milton G. Shaw and Sons Store. David T. Sanders had a small store on the west side of the street. Across the street from the church and school were three homes and a barn. Shaw Block, built thirty years later in 1893, is located on the site of a home near the center of the image. Most of the open land in the foreground was owned by M.G. Shaw or J.H. Eveleth. The fence is along the street behind the Eveleth House. The surrounding landscape was cleared by locals, to be used by horses, cattle, oxen, sheep, and pigs. (H.A. Sanders Jr.)

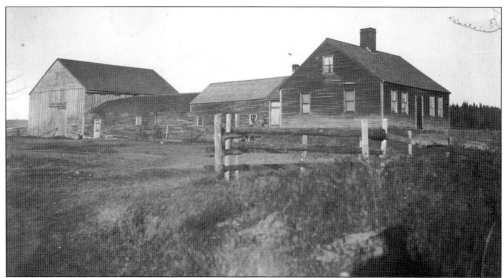

The early Varney home in Greenville, c. 1900. This was the first house built in Greenville. The house has been featured in several books on Greenville and the region and was photographed by many people prior to being torn down for the construction of Greenville Municipal Airport in the 1940s. According to Dave Curtis, "This place/Varney place built few months after Grant Place" (1825). (H.A. Sanders Jr.)

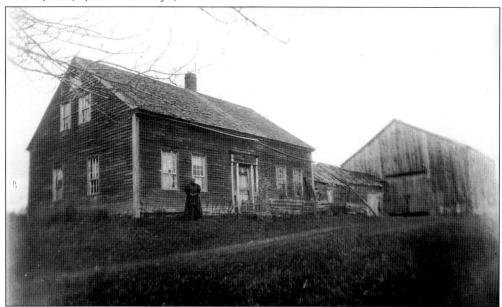

The early Darling home in Greenville, c. 1900. The home is Cape style with an ell and large barn. The downstairs windows are nine over six panes. The roof is cedar shingle. According to H.A. Sanders Jr., the building was "Built in 1825 by Stephen Darling whose daughter married Jason Grant. This place was also known as the Grant Place. The woman is Emily Darling Grant sister of Mrs. Bill Shaw and aunt of Henritta Clark Bigney Gould—Dave Curtis says this house was built shortly before (same year 1825) the Varney place which was torn down when the airport was built in 1943" (November 3, 1955). This photograph was taken by David Curtis, c. 1900. (H.A. Sanders Jr.)

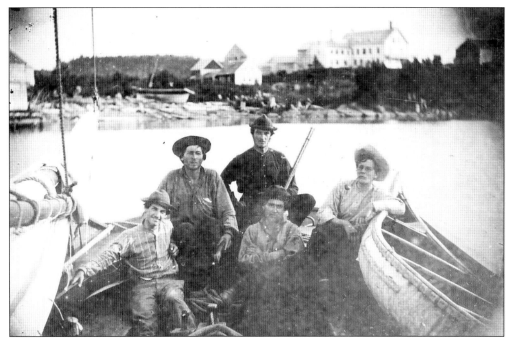

A boat party at Greenville Village, 1870s. On the hill in the background is the original Eveleth House. A birch bark canoe can be seen to the right. This photograph is from a daguerreotype original, and is one of the earliest photographs featuring the Eveleth House taken from the water. The sailboat on the shore resembles one featured in an 1870s stereoscopic view card. Still Sawyer and Harry Sanders Jr. debated the location of the picture, and the authors concur with Harry. The photograph originally belonged to Harry Sanders Sr. (H.A. Sanders Jr.)

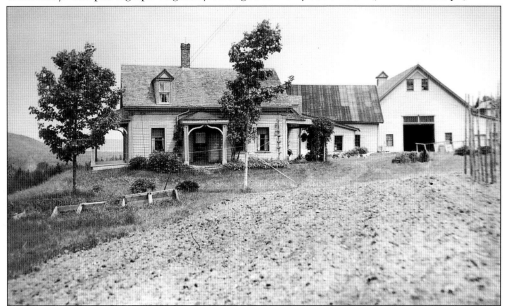

The Sloper Farm, one of the earliest houses in Greenville, 1930s. This photograph was featured in *100 Years on Moosehead Lake: History of Greenville*. The farm is on Blair's Hill. (H.A. Sanders Jr.)

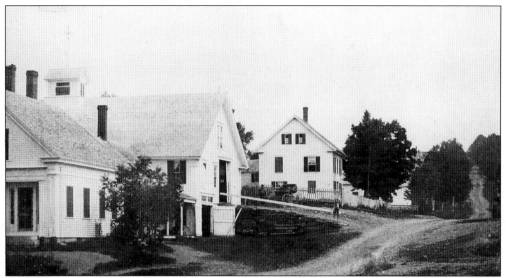

Houses at the bottom of Pleasant Street in Greenville Village. The house on the left was the nineteenth-century residence of C. Gower, and later Milton G. Shaw. The structure currently stands adjacent to the Shaw Public Library, a gift to the town from Charles D. Shaw in 1925. According to H.A. Sanders Jr., "The barn burned but the house was saved by a bucket brigade." The second house up the street has a carriage in the yard, and was the residence of B.F. Bigney. Later, it became the Folsom home. (H.A. Sanders Jr.)

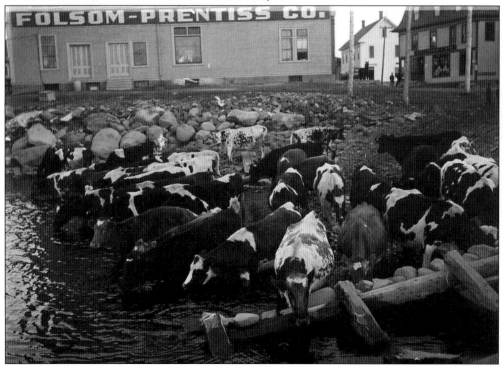

Cattle drinking in Moosehead Lake at Greenville Village. The Folsom-Prentiss Co. store in the background occupied the Shaw Block. Today this spot, formerly a boat launch, is now the landfilled Henry David Thoreau Memorial Park.

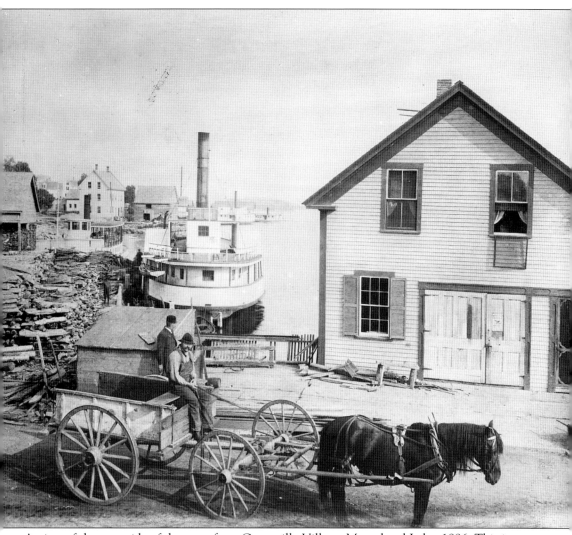

A view of the west side of the cove from Greenville Village, Moosehead Lake, 1886. This is a well-known historic photograph of Greenville which features four boats: the *Fairy of the Lake*, *Rebecca*, *Parker*, and *Louisa*. The piles of wood were important fuel for the boats on the lake. D.T. Sanders was the lake agent for the Coburn Company and purchased, cut, and stockpiled five to six hundred cord of wood for the boats annually. Shown here is Everett Parsons and "Silas" the horse. This was H.P. Sawyer's mill team which delivered clapboard edge cuts scraps for use as boat fuel. The building in the foreground later became Sawyer Brothers Store. (H.A. Sanders Jr.)

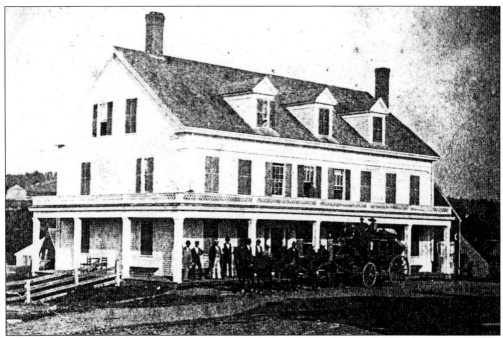

The Eveleth House in Greenville, 1870s. John Eveleth moved to Greenville from Monson and established a store in 1848. The inn was built a few years later and burned about 1900, but the foundation can still be seen. This photograph was taken by D.C. Dinsmore, of Dover, Maine, and sold as a stereo view card. (MHPC)

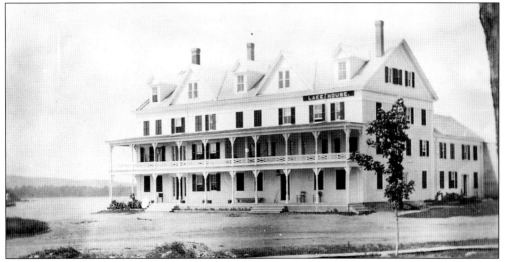

The Lake House in Greenville. The four-horse stage line was the principal means of transportation to Greenville prior to the arrival of the train in 1882. The first Lake House sign is on the second porch, and the shutters for the third floor and east end are mostly closed. The first structure here was built in 1835 and called the "Seboomook House." This building burned in 1848. The ell was rebuilt on the house in 1848, and the main structure was restored in 1849. After the Civil War the house became known as the Lake House, and it burned again in 1897 or 1898. C.D. Shaw later built a lumber operations office on the site, which is currently occupied by Fleet Bank. (H.A. Sanders Jr.)

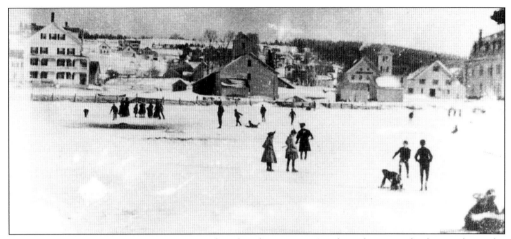
Winter playing and skating on Moosehead Lake, c. 1895. This photograph shows the Lake House on the left, the M.G. Shaw and Sons Store in center, the D.T. Sanders Store with its three-story tower on the right, and Shaw Block. (H.A. Sanders Jr.)

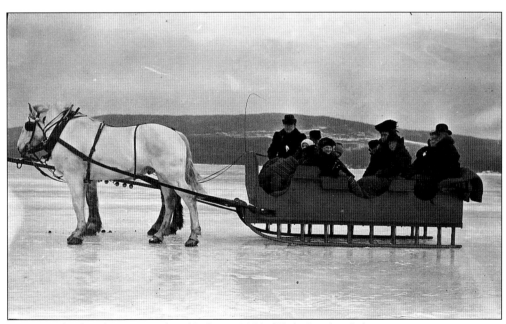
A winter sleigh ride on Moosehead Lake, c. 1900. (H.A. Sanders Jr.)

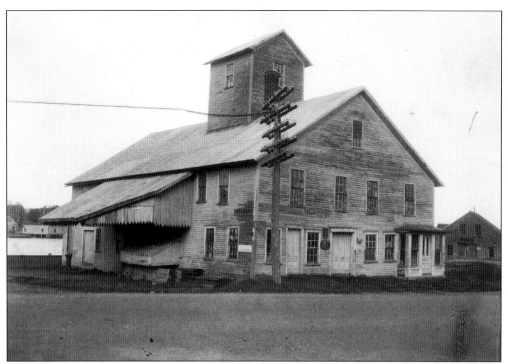

The old grist mill in Greenville, 1930s. The building was built by Charles W. Gower in 1845 and owned by Joshua Fogg and Gower who sold it to M.G. Shaw. Shaw purchased the structure in 1861 and in the 1880s it was the site of a store managed by C.D. Shaw, his son. The mill fell into disrepair in the 1930s and was torn down. According to H.A. Sanders Jr., "The mill looked like this when we went to Town Meeting and looked like the next photo a week later. Walter Boothwart and his brother George tore it down." The mill was transferred from M.G. Shaw to J.H. Hildreth and D.T. Sanders in 1862. Charles D. Shaw left the property to the town of Greenville, and the site is currently the town parking lot used by passengers on the *Katahdin* boat. (H.A. Sanders Jr.)

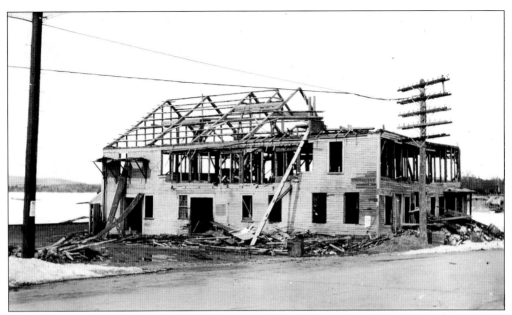

The old grist mill in Greenville, 1930s. The top of the mill was taken off first in deconstruction. On the right is the office of the Shaw Lumber Co. This building was later known as the "Green Parrot." In 1972, the Green Parrot was torn down to allow the construction of the "new" Guilford Trust Company Bank, which is now the office of Fleet Bank. (H.A. Sanders Jr.)

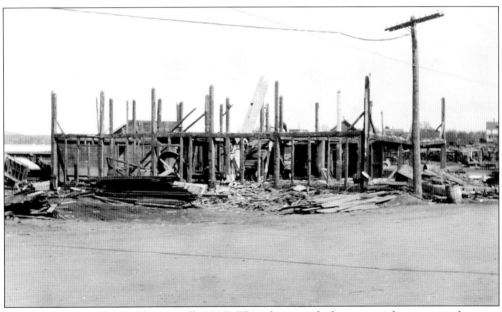

The last vestiges of the old grist mill, 1937. This photograph documents the process of tearing down the mill. The lower four rungs of the old telephone pole were removed as a single line, and remained in use. These photographs were on display in Sanders Store until the 1970s. (H.A. Sanders Jr.)

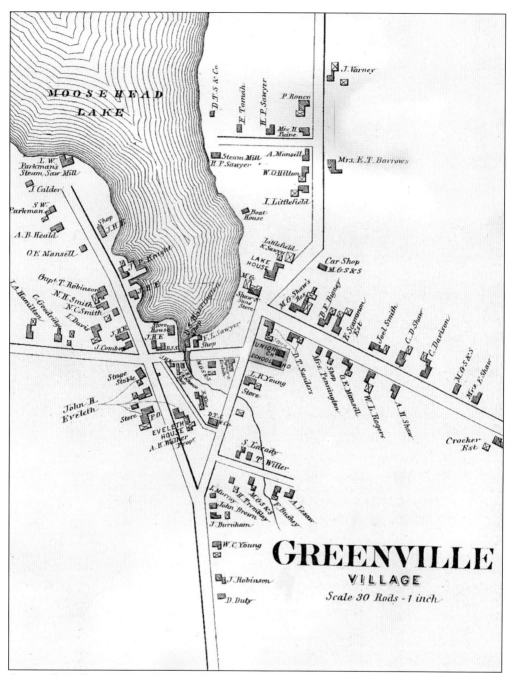

Greenville Village, 1882. This map illustrating the town is from the *Atlas of Piscataquis County* published by G.N. Colby. From 1870 to 1880, the regional population went from c. 550 to 800 people.

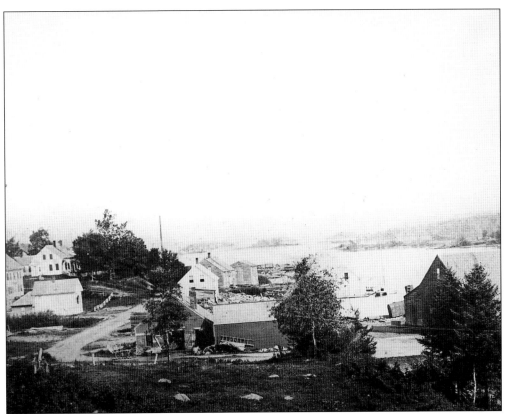

The following is a caption by H.A. Sanders Jr. concerning the above photograph: "Barn on right was taken down and is now Bill Marsh's Garage on old Meservey farm on Shirley Road. White house on floating raft with flagpole was moved over in front of Edie P. Cates at Jct. Later there was a long veneer storage shed and white building, now Sanders Boat House. Extreme left shows edge of Betsey Snow's steps, later burned. Naem Smith House is tall building on left. Later Dr. Hunt's and now Fred Bigney's. Robinson Place on knoll on left and now Still Sawyers. Pete Brocher's shop in center foreground." (H.A. Sanders Jr.)

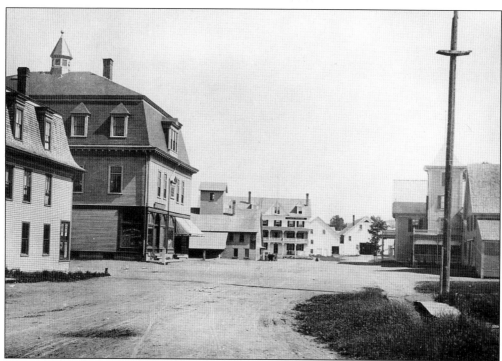

Greenville Village in the mid- to late 1890s. The Shaw Block with its Mansard roof was built in 1893 and is the large building at the left. The old Gower Grist Mill is to the right and further up the street is the Lake House with two attached barns. On the right side, behind the village flag pole, is D.T. Sanders and Son Store with its front tower under construction. (H.A. Sanders Jr.)

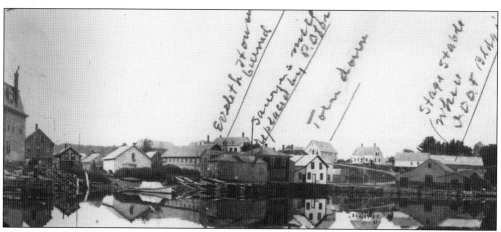

The west side of the cove in Greenville as viewed from the top of Shaw Block, 1920s. All four of the buildings at water's edge were torn down between 1932 and 1961. The handwriting is H.A. Sanders. (H.A. Sanders Jr.)

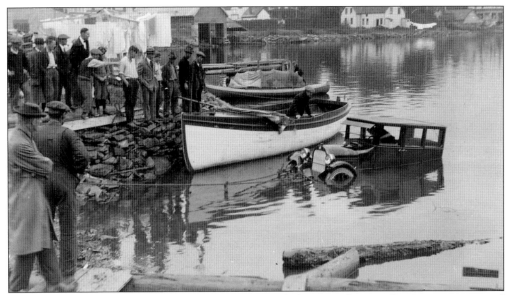

Several people who looked at these photographs said this was when Molly Mountain reversed the car into Moosehead Lake and Woody Bartley jumped in and saved her life. Woody, the father of Tony Bartley, reportedly received the Carnegie Medal for this act. The caption written by H.A. Sanders Jr. reads "Rescuing the Durant of John Brown after he backed off of the wharf." (H.A. Sanders Jr.)

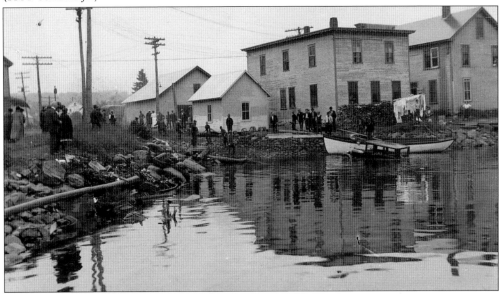

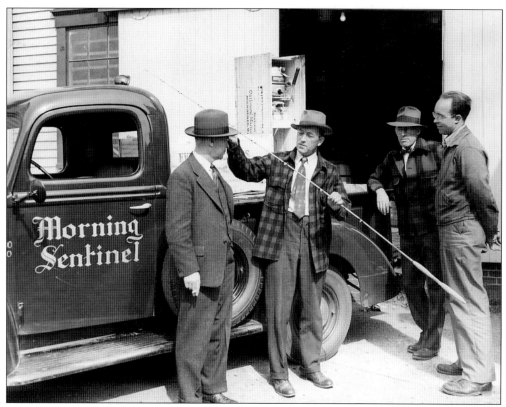

Discussing the 1945 Moosehead Lake Fishing Tournament over a fly rod at Sanders Store. The man on the left was from the *Morning Sentinel*. Charlie Lanterkin is holding the rod, Harry A. Sanders Jr. is wearing the hat, and Francis Crowley is to the right of him. (H.A. Sanders Jr.)

Engraved stationary for D.T. Sanders and Son, Greenville, 1900s. The engraving features a view of the Eveleth House and the village as seen from Indian Hill. The illustration was likely taken from the Vose stereo view card. The snowshoes exhibit fine mesh work and lamp wick boot ties that were commonplace from the 1860s through the early 1900s.

An 8-foot-tall snow drift in front of the Harris Drug Store, 1910s. Anyone who has spent a few winters in the area can attest to the conditions in January. The Union Church and D.T. Sanders and Son are behind the drift. (G.D. Hamilton)

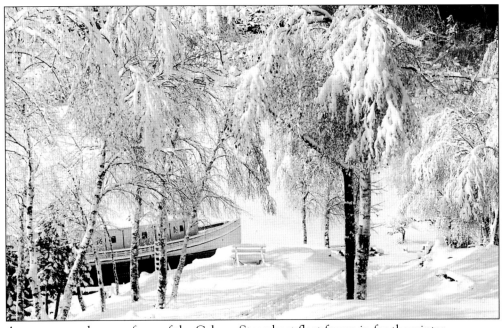
A snow-covered scene of one of the Coburn Steamboat fleet frozen in for the winter.

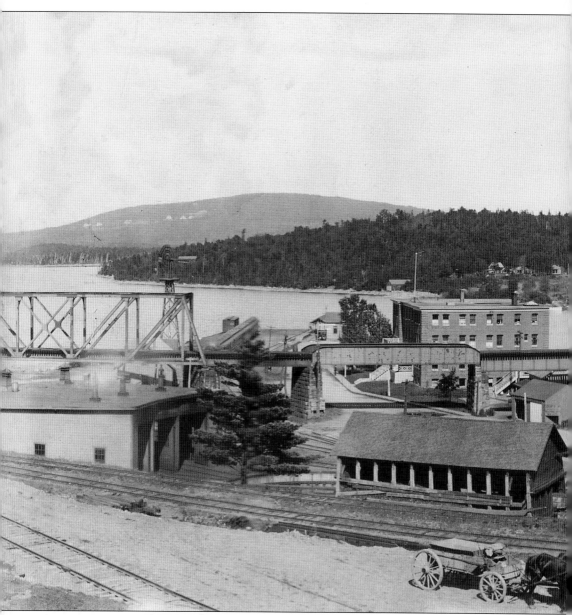

A panoramic view of Greenville Junction, 1921. Greenville Junction was originally known as "West Cove" by townspeople until the arrival of the Bangor and Piscataquis Railroad in 1884. The Canadian and Pacific Railroad line arrived a few years later in 1889 and economic growth continued from that point on. The B&P station was among the first buildings constructed and was originally closer to the present CPRR trestle. In this picture, the B&A station has been moved across from the present bridge. Although the railroad tracks were taken up in 1938, the

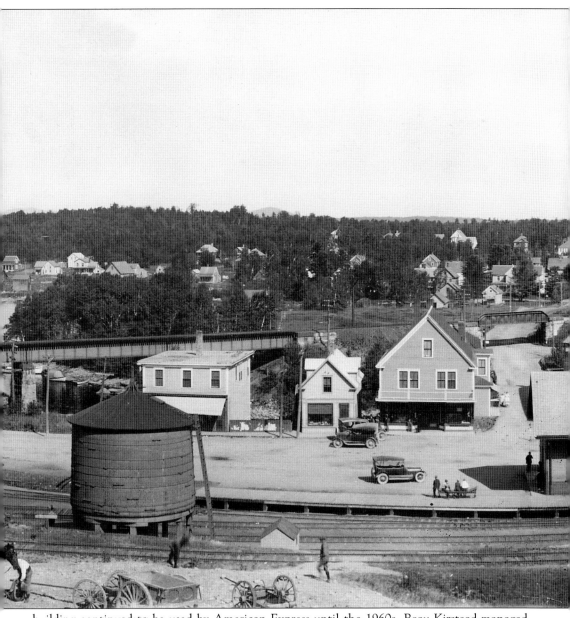

building continued to be used by American Express until the 1960s. Beau Kirstead managed the facility for the last twenty years and the building was town down in late 1960s. The large building on the left beyond the trestle is the YMCA building, and at the end of the dock is the ticket office of the Coburn Steamboat Company. The photograph was taken by A.F. Orr, 148 Main Street, Bangor, Maine. (G.D. Hamilton)

The first hospital in Greenville Junction, 1920s. The small building to the left is the location of today's hospital, the Charles A. Dean Memorial. (G.D. Hamilton)

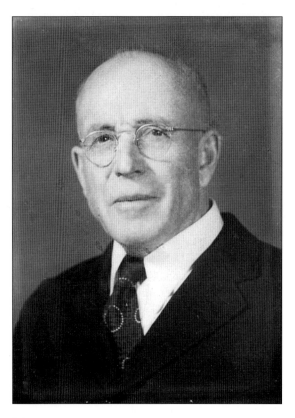
Fred Pritham, M.D., c. 1940. Dr. Pritham was a Bowdoin College graduate who moved to Greenville from Freeport, Maine. Fred was a practicing physician in Greenville Junction for over seventy years and reportedly delivered some 2,600 children. His biography entitled *The Big Little World of Doc Pritham* was written by Dorothy Clark Wilson. Dr. Pritham was a modest man and a great humanitarian. (G.D. Hamilton)

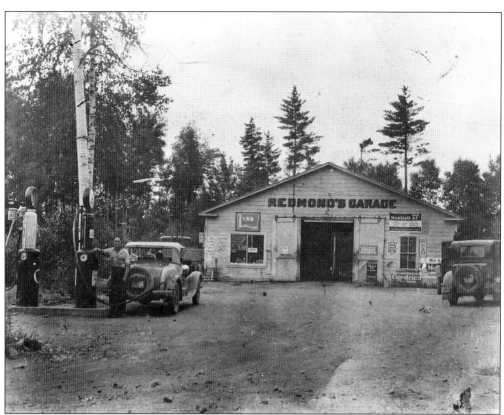

Redmond's Garage at Greenville Junction, c. 1930. Mr. Perley Redmond, proprietor, is shown fueling up at the Tydol gas pump. The garage was built in 1920, and today is G.D. Hamilton Antiques.

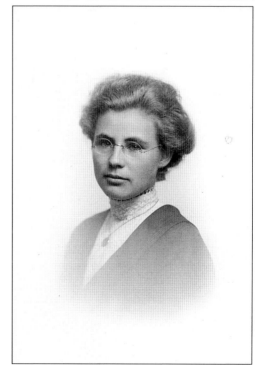

Viola Ring Redmond in 1912. This is the year she moved from the family homestead and farm in Freeport, Maine, to Greenville. She is presently Greenville's oldest resident, at over one hundred years. She first worked at Arthur Crafts' store at the Junction, while living with her sister and husband, Sarah and Fred Pritham. Shortly thereafter, she became a telephone operator of the main switchboard at Grant Farm. In 1923, Viola became Maine licensed chauffeur #1345 soon after establishing Redmond Garage with her husband (see above). She is the last surviving member of the 1928 founders of the Moosehead Lake Woman's Club.

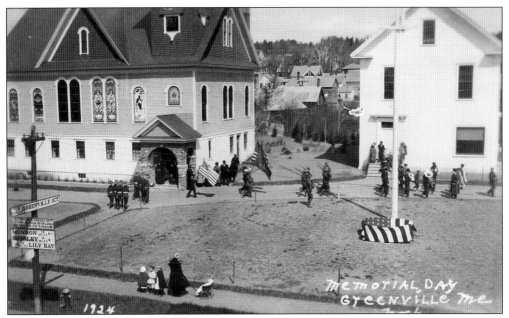

A memorial service at the town flag pole in front of the Union Church and town office, 1924. The telephone pole has a speed sign restricting drivers to 15 mph. (G.D. Hamilton)

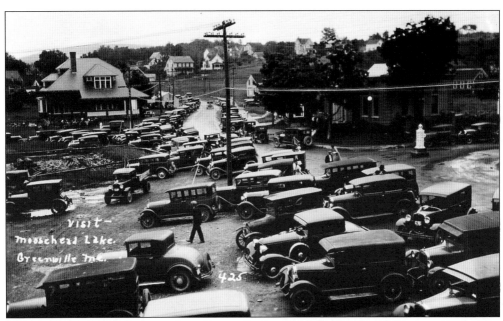

Over ninety automobiles arrived in Greenville for this July Fourth celebration, 1920s. The building on the left was originally the William R. Shaw Lumber Office and later the Green Parrot. Fleet Bank now stands here with the passenger parking lot for today's *Katahdin*. (H.A. Sanders Jr.)

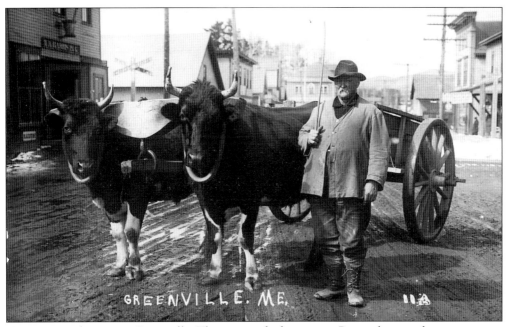

Two oxen and a cart in Greenville. The man with the team is Preo, who raised two enormous oxen: one was 7 feet 7 inches tall, and the other, 7 feet 11 inches tall. (G.D. Hamilton)

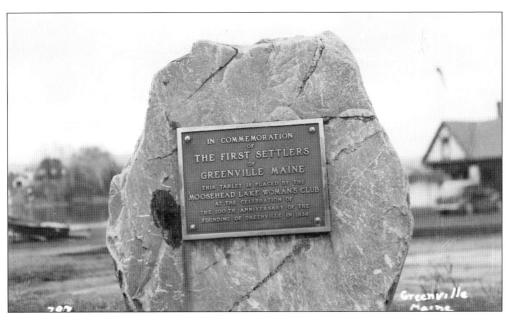

The bronze plaque commemorating the 100th anniversary of the settlement of Greenville, 1936. The plaque was dedicated by the Moosehead Lake Woman's Club.

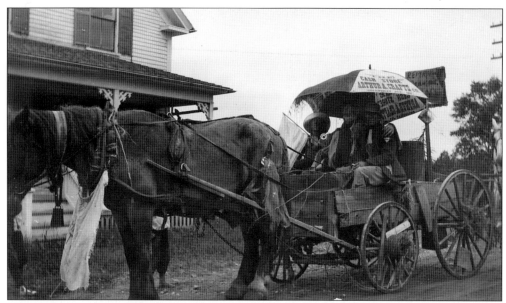

The Arthur A. Crafts Co. ("The Cash Store") horse and carriage in a July Fourth celebration, Greenville, 1920s. (G.D. Hamilton)

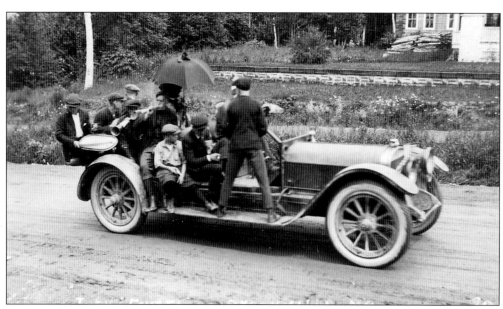

A car of young men at a Fourth of July celebration, Greenville Junction, 1920s. (G.D. Hamilton)

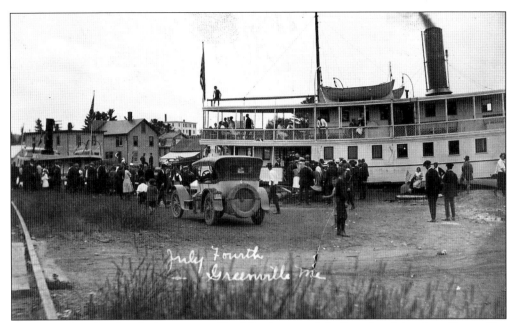

People at the wharf with the steamer *Katahdin* during a July Fourth celebration, Greenville, 1920s. (G.D. Hamilton)

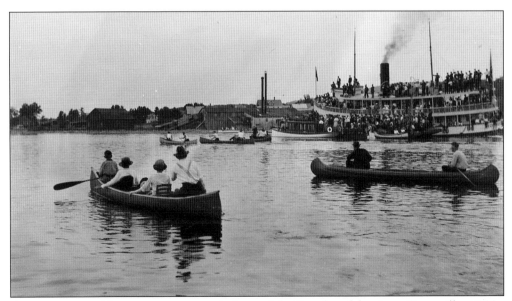

A canoe race with many spectators during a July Fourth celebration, Greenville, 1920s. (G.D. Hamilton)

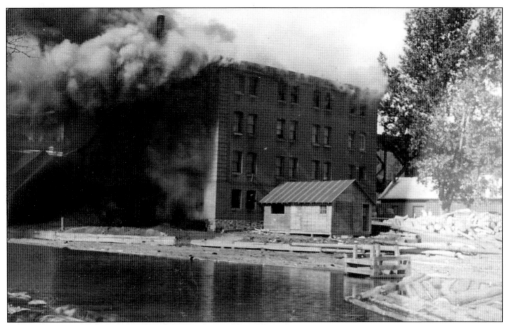

The old YMCA at Greenville Junction Dock, 1920s. The building was later used by Dave Ward and Sons for furniture manufacturing and caught fire in September 1943. It was eventually torn down and the land purchased by the town in the 1960s; it is currently being used as a public parking lot. (H.A. Sanders Jr.)

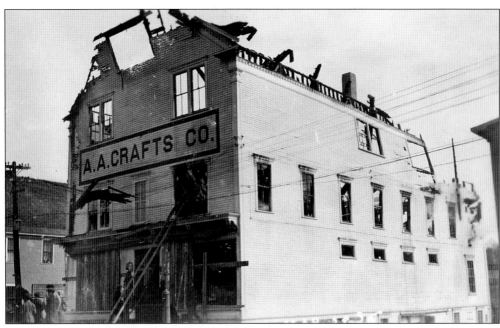

The Arthur A. Crafts' store burned at Greenville Junction, 1926. The top was repaired and still stands next to Outlet Brook bridge.

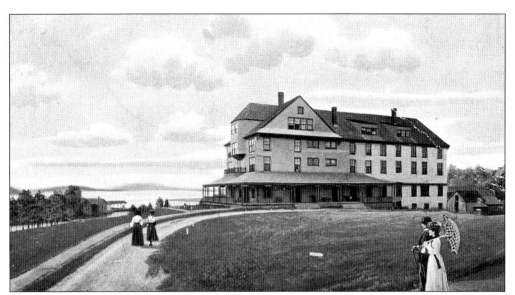

Moosehead Inn at Greenville Junction, 1890s. The hotel was built in the 1880s and managed by A.J. Walker and later Henry N. Bartley. It burned in 1912. Currier's Air Service is now located on the site of the hotel foundation.

Women and children relax on the lawn, 1890s. (H.A. Sanders Jr.)

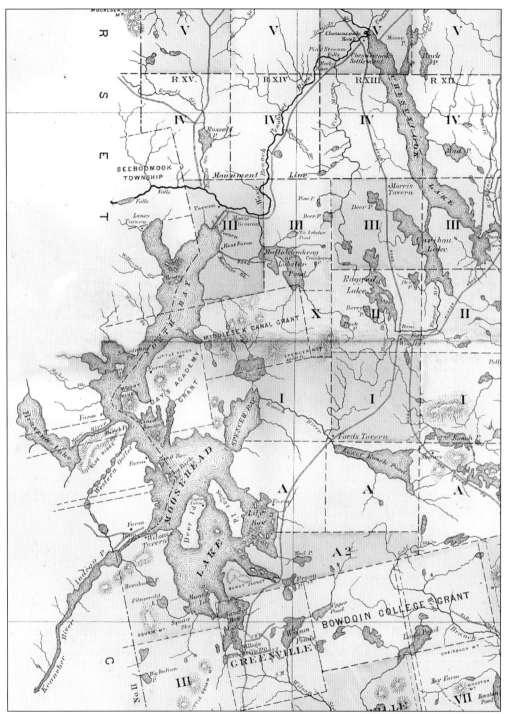

G.N. Colby's *Atlas of Piscataquis County*. Here is a section of the large foldout map of northern Maine. Many guides in the region used a canvas-backed version in orienting "outsiders" about the woods of northern Maine.

Two
Places Around Moosehead Lake

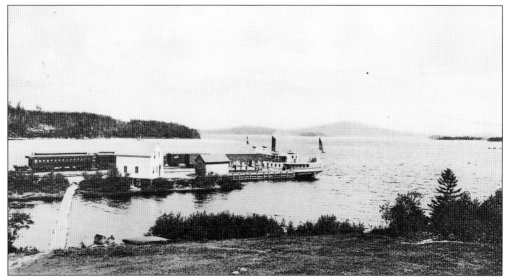

The landing at Greenville Junction, 1890s. According to H.A. Sanders Jr., "When the Moosehead Inn was doing business, the float walk ran up to the hotel." This photograph was very popular as a postcard.

After Greenville became established at the foot of Moosehead Lake, a number of farms and way houses were established around the lake. Through the nineteenth century many of the houses grew into hotels or sporting camps and prospered on a seasonal basis. Changes in transportation and economy had a profound effect on the local situation.

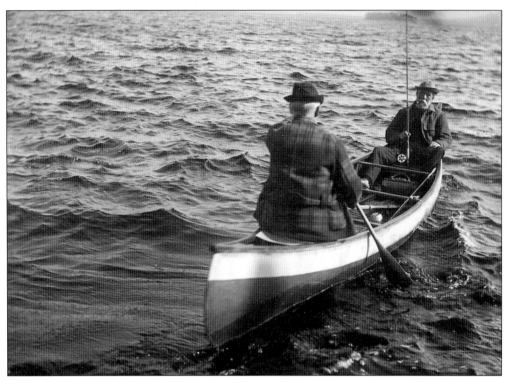

Two men fly fishing from a 20-foot canoe on Moosehead Lake, 1890s. Sam Cole is paddling the canoe, and Mr. Sawyer is fishing with a split bamboo rod with reel. The men are fishing near Camp Comfort.

Sam Cole standing in a 20-foot canoe in front of Camp Lucky and Camp Comfort, Moosehead Lake, 1890s. Many men camped, hunted, fished, and drank here. Local photographers recorded the trips of parties arriving by train from Portland, Boston, New York, and beyond.

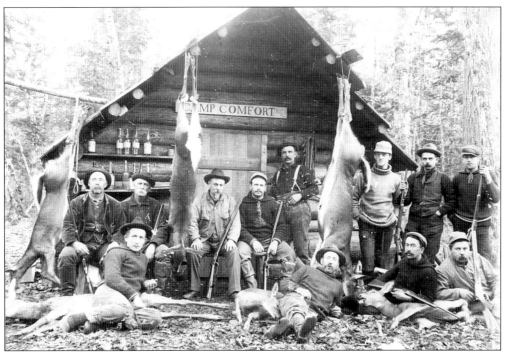

A deer hunting party at Camp Comfort on Moosehead Lake, 1890s. The party included twelve hunters, ten rifles, six deer, and twelve bottles of whisky on the wall. Sam Cole is second from the left.

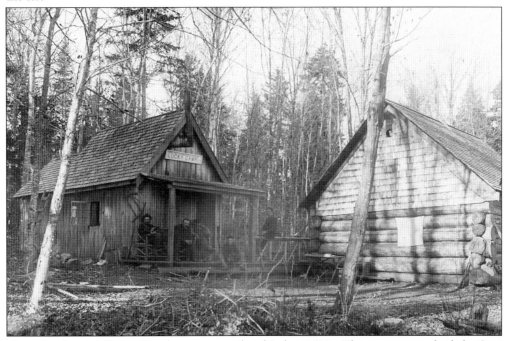

Camp Lucky and Camp Comfort on Moosehead Lake, 1890s. The camps were built by Sam Cole and Mr. Sawyer and dedicated October 25, 1884. Camp Lucky and Camp Comfort were very popular with hunting and fishing parties prior to the turn of the century.

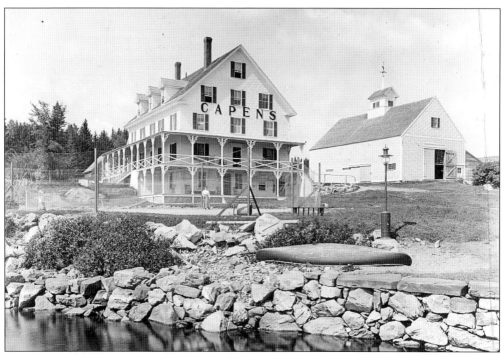
Capen's Hotel, Sugar Island, Moosehead Lake, c. 1890s. A newly constructed tennis court was in front of the hotel.

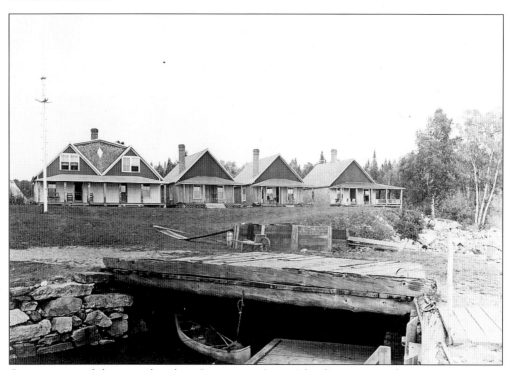
Cottages east of the main hotel at Capen's on Sugar Island, c. 1890s. The granite dock was constructed to shore-up the lake after the arrival of railroad service.

DEER ✹ ISLAND ✹ HOUSE.

AARON CAPEN,
PROPRIETOR

MOOSEHEAD LAKE, ME.

This house is delightfully situated for charming views, pure air, fishing, boating, and pleasant rambles.

It has accommodations for 30 guests. It new in every respect, with large rooms and spacious halls.

Fresh vegetables, rich milk, etc., furnished abundance from the Capen farm on the Island.

To those wishing a few weeks of healthful restful vacation in hot summer, away from crash and confusion, no more quiet and homelike pla can be found.

ROW-BOATS and CANOES

constantly on hand and guides furnished.

A Steamer in Connection

with the house for the accommodation of parti may be chartered at any time.

Boat connections and mail daily

For futher particulars, address

AARON CAPEN.

A Deer Island House advertisement, 1889, taken from *A Summer at Moosehead Lake*. In the early 1830s Aaron Capen and his son purchased Deer and Sugar Island for the cutting of virgin white pine. Aaron Sr. was a Brigadier General in the Army and was one of the key men in the War of 1812. His family was among the original settlers of Dorchester, Massachusetts.

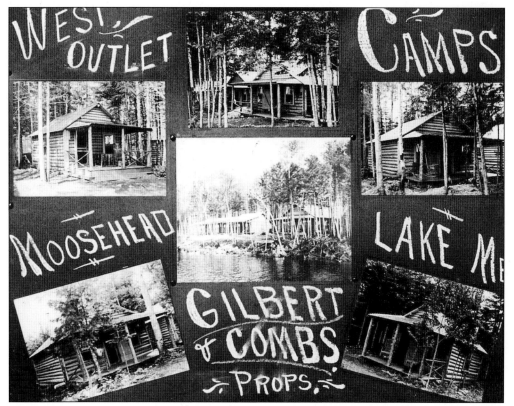

West Outlet Camps on Moosehead Lake. H. Gilbert and H. Coombs were co-owners of this popular set of camps. In 1909, twenty-four log cabin buildings were in use. The Coburn Steamboat Co. made regular stops here.

A log cabin at West Outlet Camps. This cabin can be seen in the top photograph on the lower left. Postcards of the individual buildings were popular for sportsmen and parties to send to friends and relatives. West Outlet had its own post office. (G.D. Hamilton)

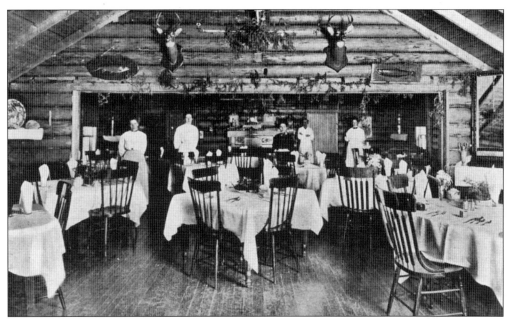

The dining room staff at Gilbert and Comb's West Outlet Camps, 1911. The photograph was featured in the *Pictorial Booklet of the Famous West Outlet Camps on Moosehead Lake, West Outlet, Maine.*

A noon meal at the West Outlet Camps, West Outlet, Maine. The menu is for Wednesday, August 4, 1909. Gilbert and Combs were the managers.

NOON MEAL.

WEDNESDAY, AUGUST 4, 1909.

Canape de Volaille

Consomme a la Royale

SLICED CUCUMBERS QUEEN OLIVES LETTUCE CELERY
PICKLES TABLE SAUCE WATERMELON PICKLES

West Outlet Corned Beef with Cabbage

Hamburger Steak au Tomat
Welsh Rarebit

Roast Prime Ribs of Beef. Dish Gravy
Young Turkey, Giblet Sauce
Spring Lamb, Mint or Brown Sauce

Cold Lamb Tongue Ox Tongue Kippered Herring Ham
Chicken Sardines

Boiled Potatoes Mashed Potatoes
Green Peas Corn on Cob Wax Beans Cabbage Pickled Beets
Hubbard Squash

Wax Bean Salad

Graham, Oatmeal and Plain White Bread
Steamed Currant Pudding, Lemon Sauce
Apple Pie Blueberry Pie Squash Pie
Chocolate Ice Cream Assorted Cake
Rhubarb Marmalade
Oranges Iced Cantaloupe Dehesa Raisins Mixed Nuts
Graham Wafers Bent's Crackers
Edam and American Cheese
Coffee Oolong Tea Milk

AN EXCURSION STEAMER LEAVES WEST OUTLET FOR KINEO AT 1 00 O'CLOCK. RETURNING LEAVE KINEO AT 5 00 P. M.

GILBERT & COMBS.

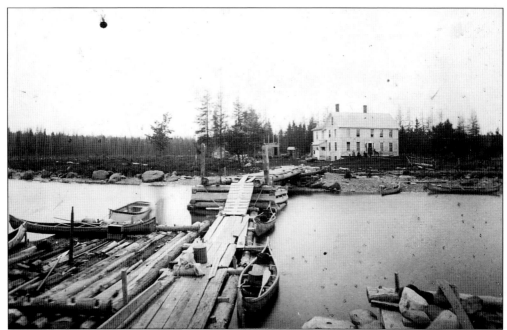

Wilson's, from the dock at East Outlet, 1878. The original photograph was by Thomas Sedgewick Steele, Hartford, Connecticut. This was the first structure at Wilson's, and was moved there by barge from the north end of the lake about 1865. Two birch bark canoes are on the shore in front of the Tavern, and four are on the dock. This photograph was taken by Steele on his first or second photographic trip to the Moosehead Lake Region. His photographs were on display in New York, as well as engraved and published in two books: *Canoe and Camera* (1880) and *Paddle and Portage* (1882). (G.D. Hamilton)

A birch bark canoe beside the second dam at Wilson's, East Outlet, 1878. This is an original photograph of Thomas Sedgewick Steele. (G.D. Hamilton)

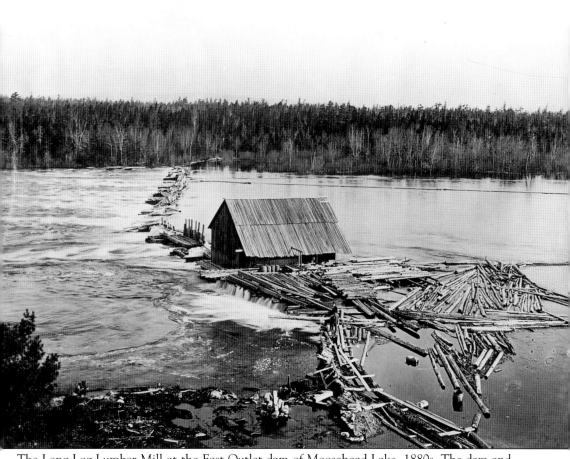

The Long Log Lumber Mill at the East Outlet dam of Moosehead Lake, 1880s. The dam and mill were constructed prior to Wilson's Tavern. This is the second dam, and is of log crib construction, likely built in the 1860s. The mill had several different owners, all of whom met with ill fates, and it was said to be jinxed. After the death of a worker, the mill sat idle for a year or two before being purchased by Henry I Wilson, proprietor of the Tavern. According to Don Wilson, Henry Wilson soon thereafter lost his hand in a mill accident. (G.D. Hamilton)

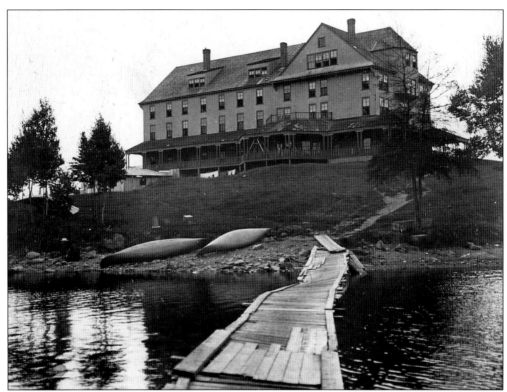

Moosehead Inn at Greenville Junction, c. 1900. The inn was originally called the West Cove House prior to the arrival of the train, when the name was changed from West Cove to the Junction. The walkway crosses Outlet Brook and connects at the Greenville Junction Dock. The inn burned about 1911. (H.A. Sanders Jr.)

A trail cut through the snow on the highway, 1920s. (G.D. Hamilton)

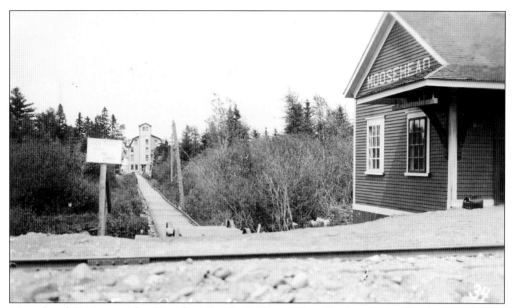

Moosehead Station on the Canadian Pacific Railway, West Outlet, 1910s. The sign reads "700 ft. to Wilsons." You can see the wooden walkway and telegraph pole to the hotel. Very few photographs of this station exist. Maria Dall, wife of Henry I. Wilson, negotiated with the CPRR to position the station on this side of the tracks. In the 1890s she received the first telegraph. (G.D. Hamilton)

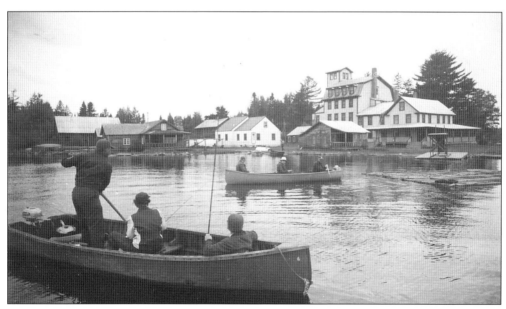

Motor boats at Wilson's Hotel and Camps, East Outlet, Moosehead Lake, 1940s. (G.D. Hamilton)

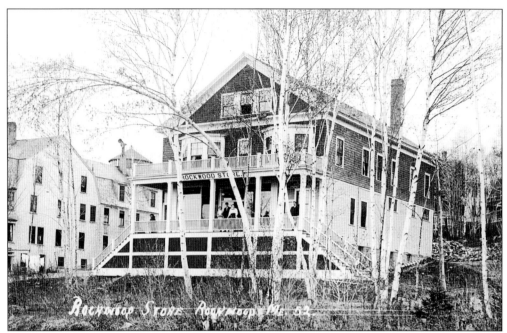

Rockwood Store, Rockwood, 1913. The store and hotel were constructed after the completion of the Somerset Railroad from Oakland to Kineo Station. The train station and boat dock were across the street. William McIver managed the store which also housed the Rockwood Post Office. (G.D. Hamilton)

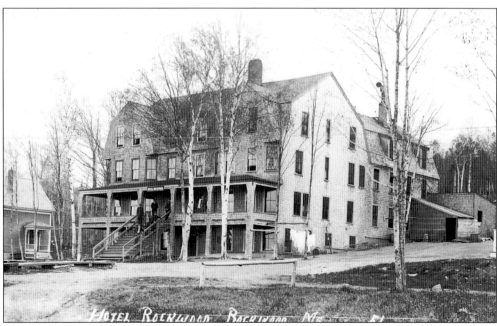

Hotel Rockwood, Rockwood, 1913. The hotel was adjacent to the store. The hotel was popular for overnight guests arriving by the Somerset Railway Company "Kineo Short Line" train from Oakland to Kineo Station.

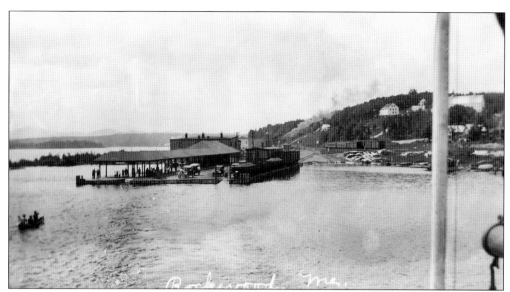

Kineo Station and the Coburn Steamboat Wharf in Rockwood, 1920s. The photograph was taken from one of the Coburn boats, likely the *Katahdin* or *Twilight*. Rockwood was first called Birch Point.

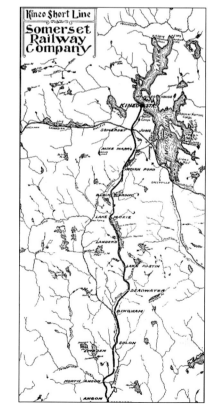

The "Kineo Short Line" of the Somerset Railway Company, published in the *Guidebook to the Upper Kennebec Valley and Moosehead Lake Region* (1909). (MHPC)

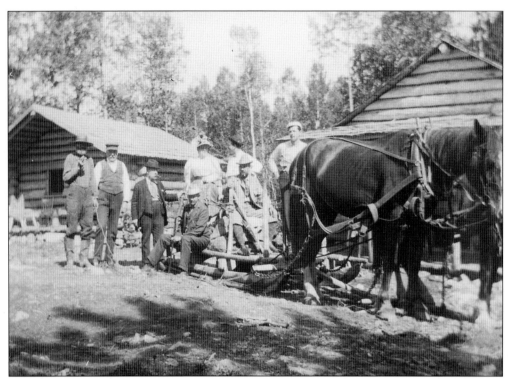

Cyrus Goodrich and party at Marr's Camps, Indian Pond, 1895. Cyrus (at left) had a home in Greenville in the 1880s, but eventually moved to the Kennebec, downstream from Wilson's on East Outlet. He ran a successful farm and supplied nearby sporting camps. (G.D. Hamilton)

The Lily Bay House on the Greenville to Chesuncook Road. This is the house for the register of 1904 (see p. 56).

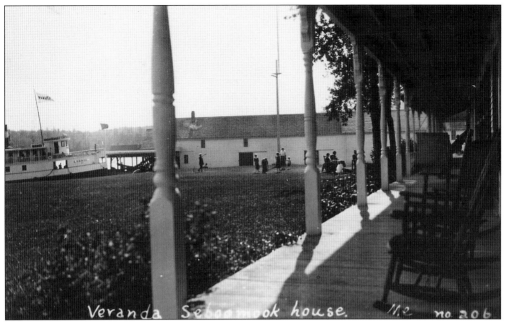

The veranda at the Seboomook House, 1920s. (G.D. Hamilton)

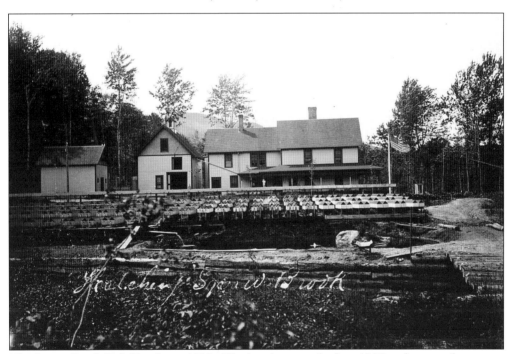

The Squaw Brook Fish Hatchery, 1920s. The hatchery was built c. 1900 and was used to spawn salmon, lake trout, and brook trout for stocking the lake. Archie Bolduc worked there for forty-two years. Archie's wife, Maud Bolduc, is a Native American. The photograph was labeled by H.A. Sanders Jr., "Old and first Squaw Brook Hatchery where murder was done, building set fire and then a suicide—Harry A. Sanders, Sr. was treasurer of a group of men who raised $1500 to give to the State toward building the Hatchery." (H.A. Sanders Jr.)

Left: Mrs. Charles Sawyer, c. 1908. This portrait was taken by D.C. Dinsmore, a photographer from Dover, Maine. (H.A. Sanders Jr.)
Right: Mr. Charles Sawyer, c. 1908, in a D.C. Dinsmore photograph. Sawyer ran the Roach River House in 1908. Later he sold it to the Hollingsworth & Whitney Company. (H.A. Sanders Jr.)

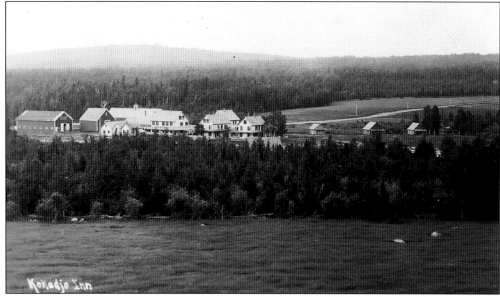

The Kokadjo Inn, formerly the Roach River House on the Chesuncook Road. The site was first occupied in 1844 by Ford's Tavern and is located on the north side of the Pond Outlet, a tributary of Moosehead Lake. This view shows First Roach Pond in the foreground. Note the telegraph and telephone poles on the road to Grant Farm and Chesuncook. The telephone was first used in 1898. (G.D. Hamilton)

The bridge at Ragged Dam, 1/4 of a mile from the Grant Farm, 1912. The top of the bridge was newly constructed in the summer of 1912 and allowed horse teams and wagons to pass. This photograph was taken by Sam Cole and sent from the Kokadjo Inn to his sister, Miss Leona Cole, on July 12. (G.D. Hamilton)

A six-horse team and wagon headed for the Grant Farm, 1912. The driver of the wagon and team is Dan Graham. The photograph was taken by Sam Cole and sent from the Kokadjo Inn to his mother, Mrs. Samuel Cole, on July 15. Two years later the road north from Kokadjo was opened. (G.D. Hamilton)

A canoeist on Spencer Pond with a view of Spencer Mountain, 1880s. This photograph is a postcard version of a photograph taken by Thomas Sedgewick Steele in the 1880s. (G.D. Hamilton)

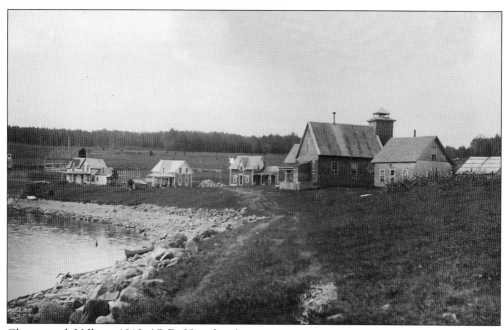

Chesuncook Village, 1912. (G.D. Hamilton)

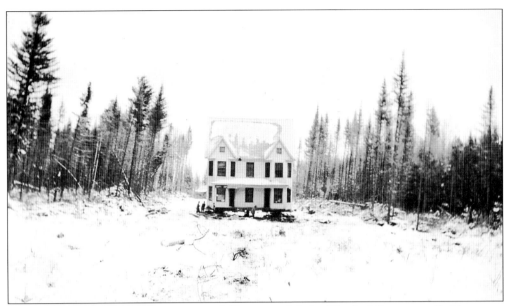

The post office building in transit toward Chesuncook Lake. The building was pulled by teams of oxen through the clearing, 1900s. (G.D. Hamilton)

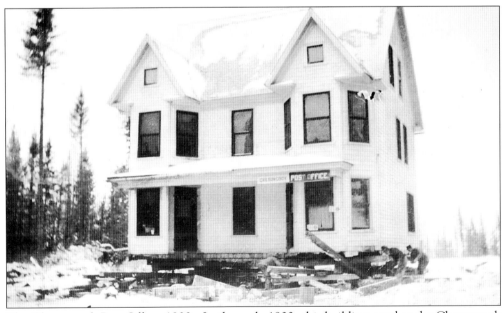

The Chesuncook Post Office, 1900s. In the early 1900s this building, used as the Chesuncook Post Office, was relocated by cutting a trail through the woods and sliding it on logs. A post office was established in 1900, closed briefly in 1906, and continued until 1955. This photograph could represent the 1906 closure. (G.D. Hamilton)

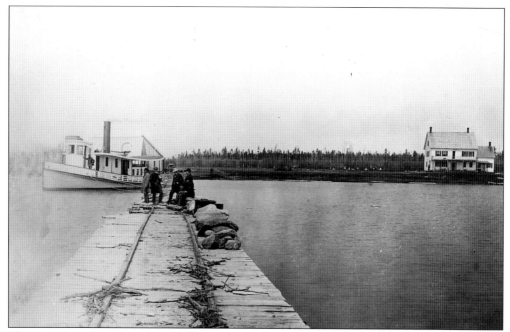

The steamboat *Louisa* at the Northeast Carry Dock. Morrison's Tavern (right) was the first building on the northeast shore of Moosehead. This is the carry to the West Branch of the Penobscot River. (G.D. Hamilton)

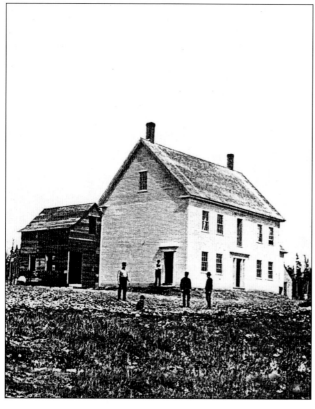

Morrison's Tavern at the Northeast Carry, 1870s. This photograph was featured as a stereo view card. (MHPC)

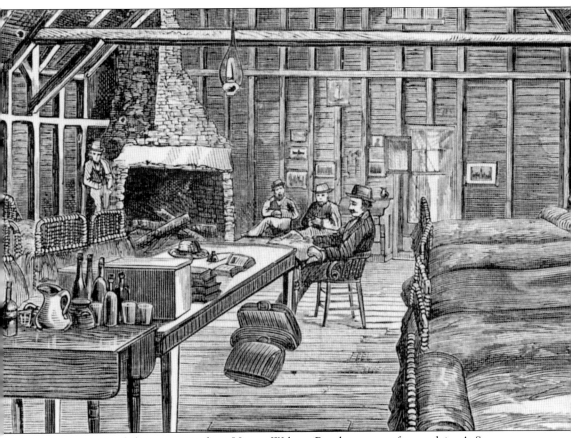
An engraving of the interior of an Upper Wilson Pond camp as featured in *A Summer at Moosehead Lake and Vicinity* (1889). The first settlement in the Wilson Pond area was made by the Walden family.

LILY BAY HOUSE,

LILY BAY, MOOSEHEAD LAKE, ME.

Guests are hereby notified that the Proprietor will not be responsible for Valuables, Money, Jewelry, etc., unless the same are deposited in the Safe at the Office.

FRANK L. GIPSON, Manager.

The Bijou Advertising Company, Publishers, Randolph, Vermont.

Name	Residence	Time	Room	Horse	Call
WEDNESDAY AUG 24 1904					
H. W. Boynton	Andover, Mass.				
W. K. Moorehead	"		"		
Ed. A. Capen	Deer Island		"		
Chas Don	"		"		
O. A. Atha M.D.	New York, N.Y.		"		
Mr. Mrs. Shray & Child	Phila. Pa.		"		
John P. Browning	Salem. Mass		"		
Ed Kane			"		
C. C. Moore			"		
Mrs. H. S. Holcomb	New Haven Conn		"		
Miss Holcomb	" "		"		
Capt Vaughan	Str. Priscilla				
Joseph Parent			"		
A. Bradeen	Milo, Maine		"		
Mrs. Lyman Blair & 3 friends			"		
Baby Lahey	Moosehead Lk Co		21		
K. B. Garrin	Howlton		8		

A page from the original Lily Bay House Register for August 24, 1904. At the top of the list are Boynton and Moorehead from Andover, Massachusetts. Moorehead later conducted an archeological survey of the Moosehead region. Mr. Capen from Deer Island managed the hotel and helped Moorehead. The other people from away were part of Moorehead's party. The crew from the steamboat *Pricella* stayed for the night. (G.D. Hamilton)

PAGE, SPEARING & CO., Complete House Furnishers, Carpets, Curtains, Draperies, Rugs, Crockery, Silverware, Tinware, **Guilford, Me.**

SPORTSMEN!

ARE you aware that we have one of the best stocks of General Merchandise in Maine, and can supply you with **everything you need in the way of a Camp Outfit!** Send for our complete list of Camp Supplies, make up your order, send it to us, and we will have the goods carefully packed and ready at the time and place desired, thus saving you trouble and annoyance. We guarantee to give you prompt service and the best of goods.
Reliable Guides engaged when desired.
Long distance telephone connection.
G. W. BROWN & SON,
GREENVILLE, MOOSEHEAD LAKE, MAINE.
We have several Cottage Lots on the shore of Lake Onawa for sale.

FIRST-CLASS DRUG STORE
AT
GREENVILLE VILLAGE.
Full line of Drugs and Druggists' Sundries in Stock.

Confectionery, Cigars, Books and Stationery.

Mail or 'Phone orders given prompt attention. If I haven't what you want will gladly get it for you as fast as mail or express will bring it.

I. A. HARRIS, Ph. G.

BUCK & CLARK,
Dealers in Choicest Qualities of

Meat,
Fish,
Vegetables

Canned Goods, Fruit, Etc.

Special attention paid to Transient Trade.
GREENVILLE, - ME.

CLOTHING, FURNISHING GOODS, BOOTS, SHOES & RUBBERS, HATS, CAPS, TRUNKS, GRIPS, SUIT CASES, ETC.

MOOSEHEAD CLOTHING CO.

Fine Fishing Tackle, Guns, Ammunition and Sporting Goods. Opposite B. & A. Station.
MILLARD METCALF, Manager. **GREENVILLE JUNCTION, MAINE.**

F. U. WITHAM & CO.,
Plumbing, Heating,

STOVES, RANGES.
Pipe and Fittings of all kinds.
Tin Roofing. Windmills and Pumps.
Pneumatic Tank Water System.
All Work Guaranteed First-class.
'Phone 21-12.
GUILFORD, - MAINE.

FOR
Groceries and Supplies,
Fishing Tackle,
Ammunition,
Gents' and Ladies Furnishings
GO TO
ARTHUR A. CRAFTS' CO.
Opposite B. & A. R. R.,
GREENVILLE JCT., ME.

Goods carefully packed and delivered to steamboat wharf or depots.

WM. SENTNER & SON,
PRACTICAL AND SCIENTIFIC
HORSESHOERS
and GENERAL JOBBERS.
Tote Sleds, Heavy Wagons, Jiggers, Neck Yokes, Bar Iron and Steel, Chains, Whiffletrees, Coal.
Band Saw and Lathe Work a Specialty.
Greenville Jct., - - Maine.

W. P. HUBBARD,
LICENSED
Undertaker and Embalmer.
Graduate of Mass. College of Embalming.
Casket and Funeral Supplies on hand, also can get anything the National Casket Co. have in Stock at short notice. **CORONER.**
Telephone. Greenville Jct., Me.

D. T. SANDERS & SON,
GREENVILLE, MAINE.

Outfitters to Lumbermen and Sportsmen.

AT IT SINCE 1857. **LONG DISTANCE TELEPHONE.**
Wholesale Warehouse at **GREENVILLE JCT.**

GERRISH BROTHERS,
Manufacturers and Dealers in
LONG AND SHORT LUMBER
On line of B. & A. and C. P. R.
Hardwood Flooring, Spruce and Hard Pine Sheathing, Moulding, Etc.
CONTRACTORS and BUILDERS.
Lime, Brick and Hair. All kinds of Building Material.
Estimates given.
GREENVILLE JUNCTION, - - MAINE.

GUILFORD
STEAM LAUNDRY
J. C. HESCOCK, Proprietor.
AGENT AT
Greenville Junction, Moosehead Clothing Co.
Also Work received by express has our Immediate Attention.

E. D. SHAW, President.
K. B. HOPKINS, Treasurer and Manager.
Greenville Machine and Foundry Co.,
GENERAL MACHINE WORK.
Motor Boats Built and Automobiles Repaired.
Patterns furnished to order.
Telephone Connection. **GREENVILLE, ME.**

F. J. PRITHAM, M. D.
Physician and Surgeon.
GREENVILLE JUNCTION, ME.
Telephone Connections.

H. E. METCALF,
JEWELER
And GRADUATE OPTICIAN.
Eyes Tested Free. Lenses and Frames always on hand.

A FULL LINE OF
Drugs and Patent Medicines.
TOILET ARTICLES OF EVERY DESCRIPTION.
FRUIT, CONFECTIONERY, SODA & CIGARS.
OPPOSITE B. & A. DEPOT,
Greenville Jct., Maine.

H. W. DAVIS, President. A. W. ELLIS, Vice President. F. B. PEASE, Treasurer.
GUILFORD TRUST CO. Capital and Surplus, **$75,000.00.** Guilford and Greenville, Maine.

An ink blotter page from one of the Lily Bay Registers. This indicates some business operating in Greenville and the Junction. (G.D. Hamilton)

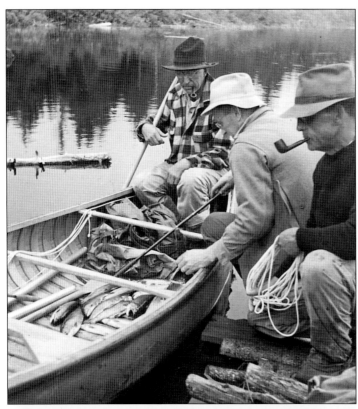

Trout fishing with a fly rod and canoe, 1950s. The party includes Paul Brown, in the canoe, and Ab Mountain. The caption reads "Fishing near Wilsons." Paul worked as a guide for Harry W. Cannon Jr., owner of Cape Canaveral with homes in Florida and New York. He was one of the best customers of the Abercrombie & Fitch Company. Canon owned the Elm Pond and Russell Pond camps. Ab Mountain worked for Harry along with Carl Woolery, Oliver Bernard, and others.

The catch, 1950s.

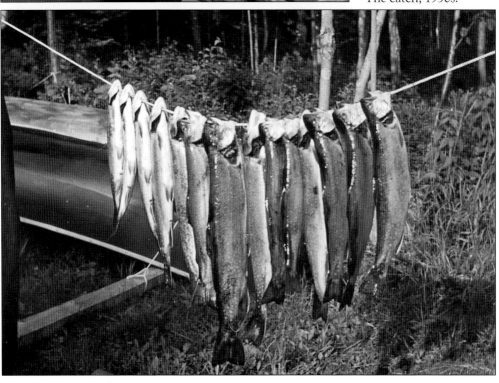

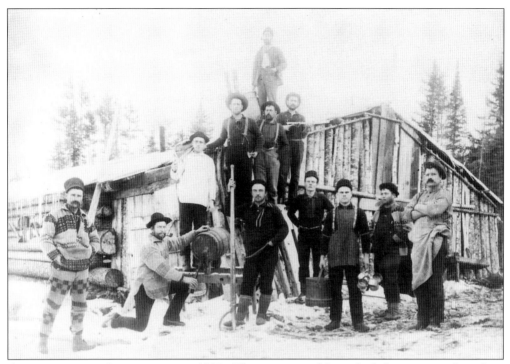

A winter crew at a logging camp, *c.* 1880s. The man second from the left is tipping a large keg toward a bottle. (G.D. Hamilton).

Engraved stationary for the M.G. Shaw Lumber Co., 1907. The engraving features a view of the mill along the Kennebec River in Bath. Three of the directors of the lumber company are sons of Milton G. Shaw. The mill was established in 1871.

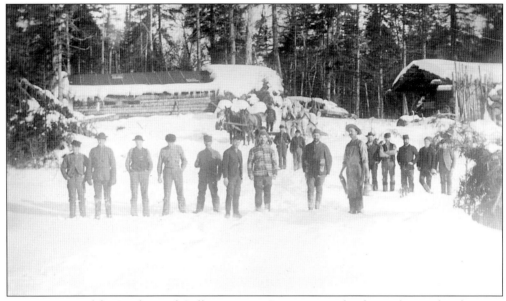

A winter crew of the Sanders and Cullen Logging Operation on the shore of Moosehead, 1890s. (H.A. Sanders Jr.)

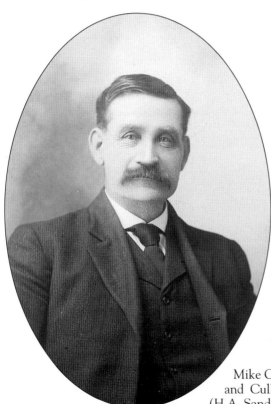

Mike Cullen, 1900s, a co-proprietor of the Sanders and Cullen Logging Operation, Moosehead Lake. (H.A. Sanders Jr.)

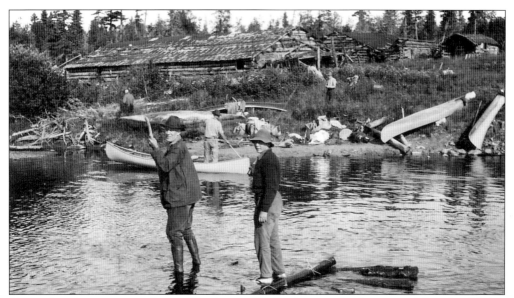

On a raft and in a canoe in front of Sanders and Cullen's winter lumber camp, Moosehead Lake, 1920s. (H.A. Sanders Jr.)

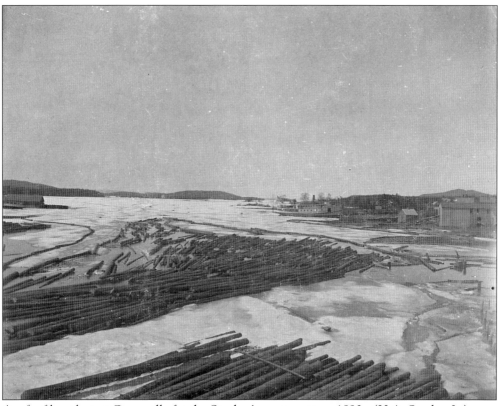

A raft of long logs at Greenville for the Sanders' saw operation, 1890s. (H.A. Sanders Jr.)

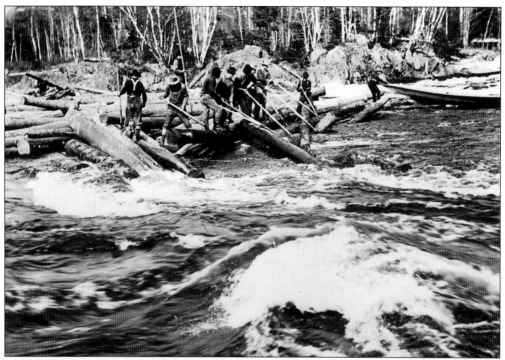
Pushing logs free from the shore, 1904. (H.A. Sanders Jr.)

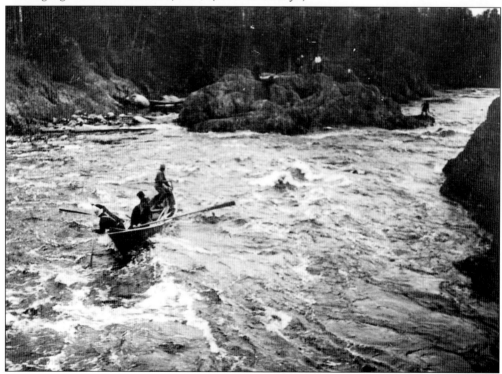
A logging crew in a bateau heading downriver, 1917. The man at the stern of the bateau is poling down the river rapids. (H.A. Sanders Jr.)

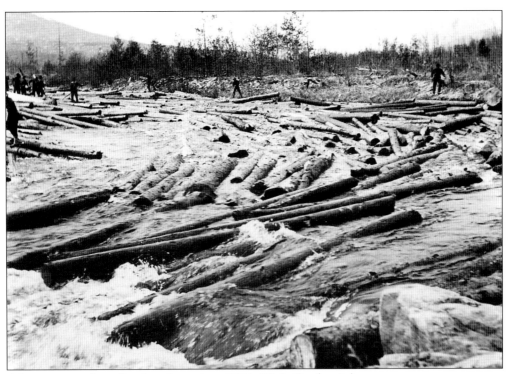

A logging crew funneling logs downriver, 1904. (H.A. Sanders Jr.)

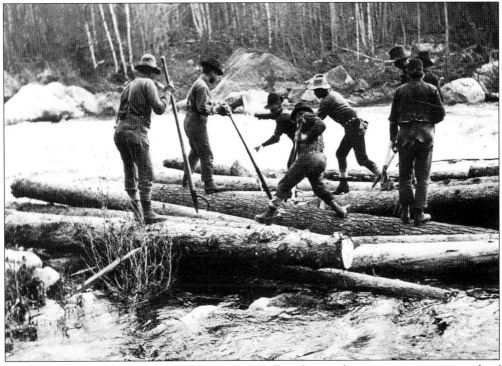

Clearing the log jam, 1904. The eight men are rolling logs with peaveys on a river north of Moosehead Lake. (H.A. Sanders Jr.)

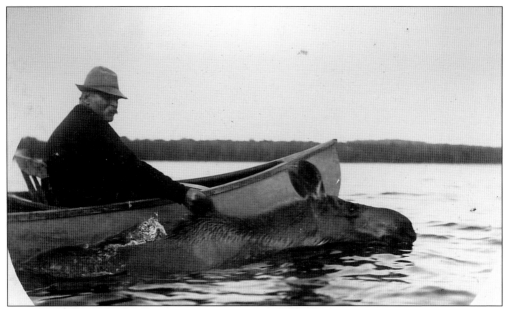

A canoe being towed by a moose, 1900s. The following four photographs were on display at Wilson's Hotel for many years. They are part of an album of thirty-six pictures documenting a trip down the West Branch to Lobster Lake. (G.D. Hamilton)

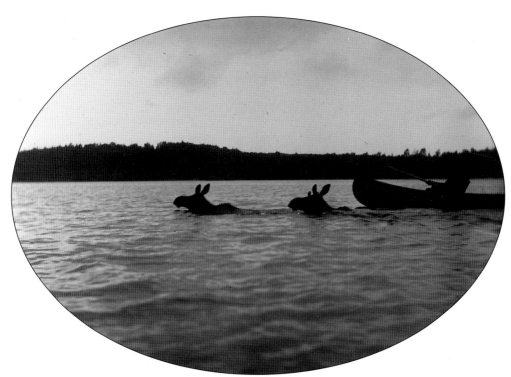

Canoeing with two moose, 1900s. (G.D. Hamilton)

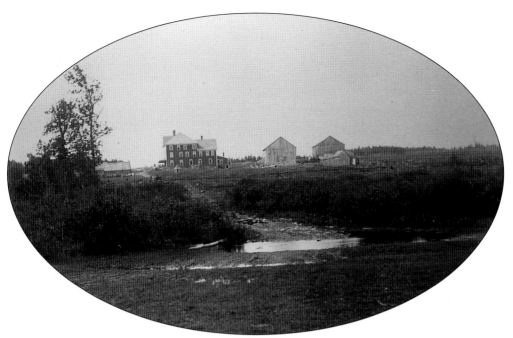

At the portage, 1900s. (G.D. Hamilton)

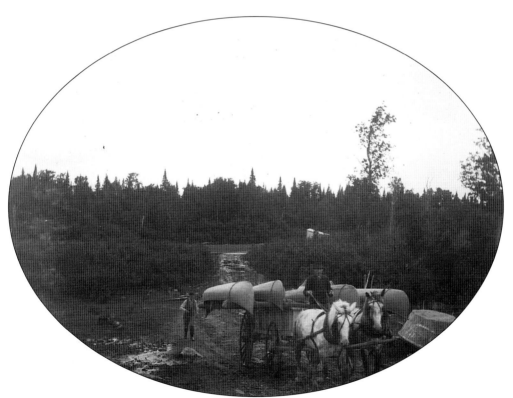

Four canoes loaded on the horse carry, 1900s. (G.D. Hamilton)

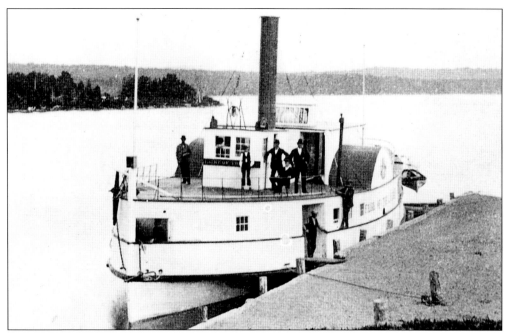

The steamboat *Fairy of the Lake* on Moosehead Lake, 1870s. In 1858, four years after building the second steamboat *Moosehead*, Major Bigney built the *Fairy of the Lake*, a side wheeler. This boat was owned by John H. Eveleth and was featured in a number of early photographs. (G.D. Hamilton)

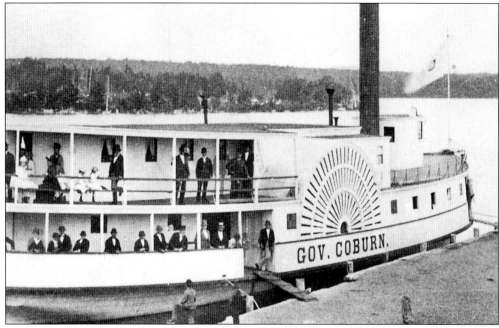

The steamboat *Governor Coburn* on Moosehead Lake, 1870s. The boat was originally built in 1872 by Major Bigney and powered by a wood-fired high Pain steeple-type engine. In the 1880s, Captain Thomas Robinson made trips from Greenville to Northeast Carry. Note the large stack for the engine; the boat also had a stained glass skylight. (G.D. Hamilton)

Three
On the Lake: Canoe, Motorboat, and Steamboat

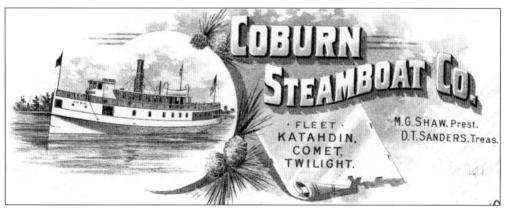

An engraved check for the Coburn Steamboat Co., Greenville, 1890s. The fleet included the *Katahdin*, *Comet*, and *Twilight*. M.G. Shaw was the president and D.T. Sanders the treasurer. The first transportation on the lake and rivers was by dugout or birch bark canoes. This form of transportation is flexible and efficient and was the norm for native peoples for over 5,000 years. In the mid-1830s a small steam boat was constructed in Greenville and the age of machine was ushered in. An important event occurred when the steamer *Amphrite* made a daylong trip to the Hildreth House at Kineo in 1845. After this time travelers and rusticators began to frequent the mountains and rivers, Thoreau a notable one. The lumber boom and general prosperity started after the Civil War and increased through the 1920s. With an increase in interest, most of the hotels and camps had small launches and some steamers. A long time after the establishment of the Moosehead Lake Steam Navigation Company in 1851 came the Coburn Steamboat Company, founded in 1892. Within a few years most of the larger boats on the lake were purchased by Coburn, who controlled the trade until the 1930s. The last vestiges of this era can be seen on the *Katahdin*, which remains in use today.

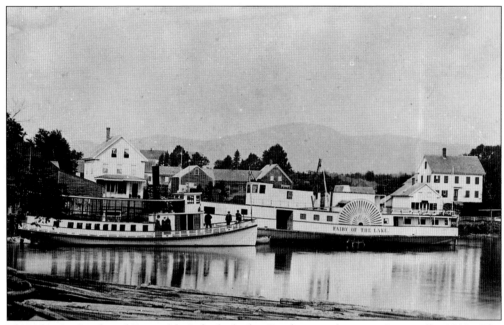

The steamers *Ripple* and *Fairy of the Lake* docked at Sanders storehouse in Greenville, 1880s. The Naem C. Smith and Captain T. Robinson Houses are in the background. (H.A. Sanders Jr.)

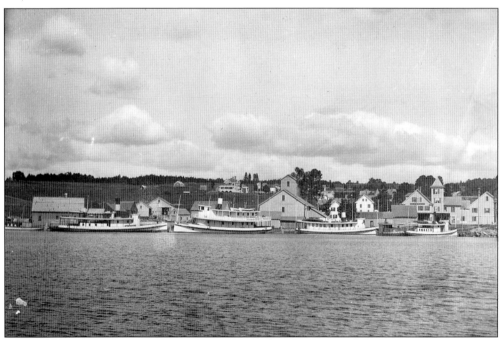

A view of five large boats in Greenville, 1900s. All of the boats are docked on the east side of the Village Cove where the *Katahdin* is currently docks. Visible on the hillside is the Victorian mansion built by William M. Shaw, now known as the Greenville Inn. (G.D. Hamilton)

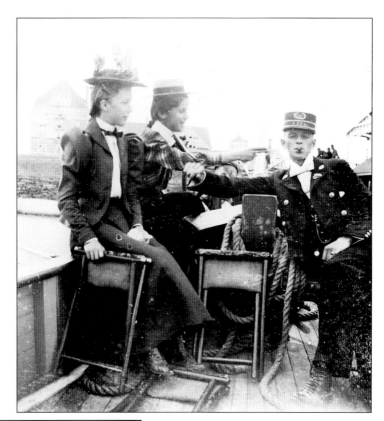

A steamboat ride on Moosehead Lake, 1890s. This photograph appeared in a photo album of Celestia Robinson Sanders when she was a young woman. (H.A. Sanders Jr.)

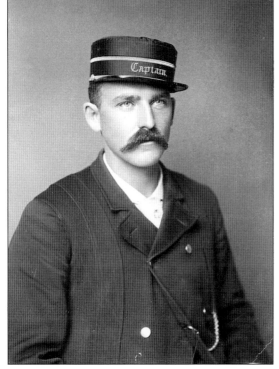

Captain Charles J. Robinson, c. 1890. Captain Robinson was the steamboat captain of the Coburn Steamboat Company. On May 13, 1913, Captain Robinson piloted the burning steamer *Katahdin* from the middle of Moosehead Lake to the shore near East Outlet, saving the lives of the ten-man crew. The steamer burned to the waterline. Lewis, the Kineo and Bangor-based professional photographer, created this image by the "Instantaneous Process." (H.A. Sanders Jr.)

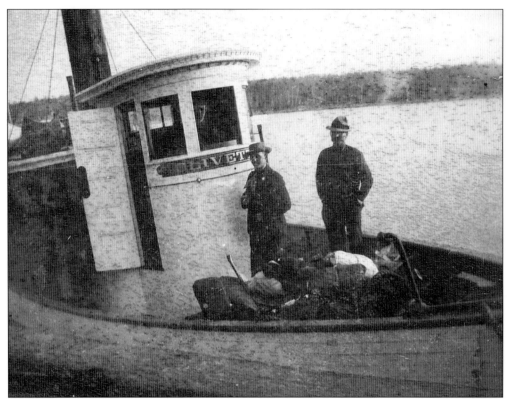

The steamboat *Olivette* on Moosehead, 1890s. The passenger has camping gear in a native American basket for a trip up the lake. (G.D. Hamilton)

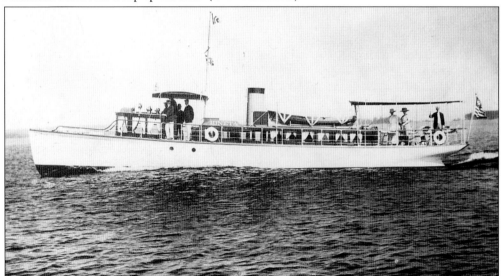

The large motor launch *Ioneta*, c. 1910. This boat was one of the flagships for the Moosehead Lake Yacht Club with its new clubhouse at Kineo. In 1909, there were fifty-seven registered members, including C. Judkin, Henry Feuchtwanger, W.H. Wesson, the Shaw brothers, and Roy Marston. The members on deck are wearing typical dress for the Saturday events. (G.D. Hamilton)

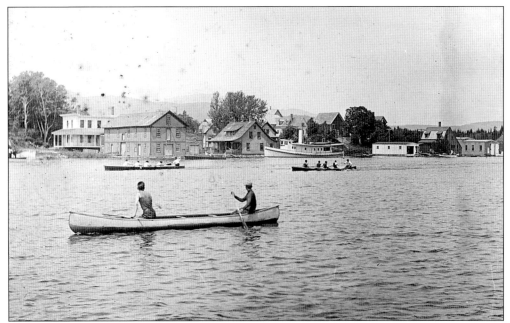

Two crew teams racing at Greenville Village, 1930s. The canoers in foreground are watching the races. The crew boats are in front of Will St. German's boat house and the boat *Louisa*. The photograph may have been taken during the 1936 centennial festivities.

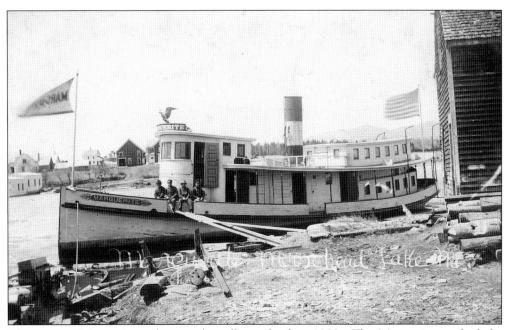

The steamer *Marguerite* tied up at the village wharf, c. 1900s. The *Marguerite* was built by Henry Sawyer for Lester Van Brunt. In the 1890s, the boat was added to the Coburn Steamboat Company fleet.

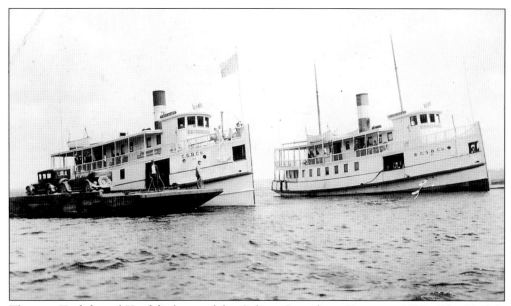

The new *Twilight* and *Katahdin* boats of the Coburn Steamboat Company, 1920s. The *Twilight* is towing a barge with cars. (G.D. Hamilton)

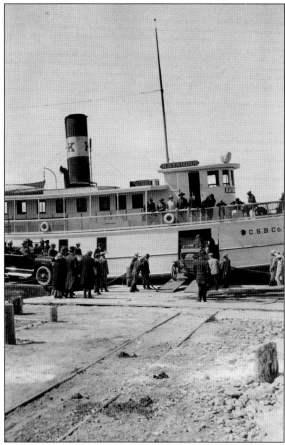

The steamer *Katahdin* at Greenville Pier, 1920s. Cars are being unloaded out of the side of the boat on plank ramps. This was a difficult task given the small door opening. (G.D. Hamilton)

Coburn Steamboat Co.

Will run their Boats through the months of August and September as follows:

Steamer Twilight

WILL LEAVE GREENVILLE AT 7 A. M., GREENVILLE JUNCTION, 7.30 A. M., DAILY, (EXCEPT SUNDAYS), FOR N. E. AND N. W. CARRYS, TOUCHING AT KINEO BOTH WAYS, ARRIVING AT GREENVILLE JUNCTION AND GREENVILLE SAME DAY.

Steamer Comet

WILL LEAVE KINEO AT 7.45 A. M. FOR HEAD OF LAKE, RETURNING SAME A. M.; ALSO LEAVE KINEO AT 2 P. M., TAKING PASSENGERS THAT COME THROUGH ON KATAHDIN AND ANY OTHERS THAT MAY WISH TO GO THROUGH TO HEAD OF LAKE, RETURNING TO KINEO SAME P. M.

STEAMER KATAHDIN

Will Leave Greenville Junction at 9.30, or on arrival of train from Bangor; returning, will leave Kineo in season to connect with train leaving Greenville Junction at 3.55 for Bangor.

The above arrangement will enable parties wishing to go through to Head of Lake same day by taking Katahdin for Kineo, and Comet for Head of Lake. It will also enable parties wishing to go from Head of Lake through to Bangor same day, taking Comet from Head of Lake in morning for Kineo and Katahdin for Greenville Junction, arriving at Greenville Junction at 3.55 P. M., and B. & A. R. R. arriving in Bangor at 7.30.

In case parties shipping horses and freight through to Head of Lake more than can be taken on Comet from Kineo, the Katahdin will continue her trip through to Carry, the Comet taking her place for Greenville Junction.

Guilford Recorder Print.

The Coburn Steamboat Company schedule for the *Twilight*, *Comet*, and *Katahdin*.

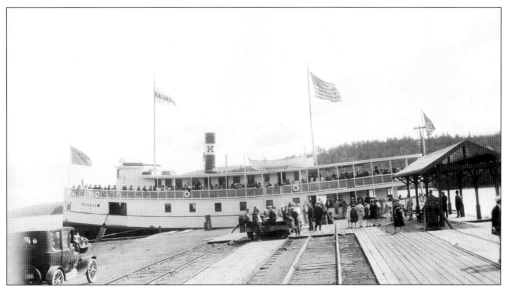

The steamer *Katahdin* at the Greenville Junction Wharf, c. 1910. The *Katahdin* has the round stern. The boat passenger waiting area had a sheltered section to help passengers ward off the weather. (G.D. Hamilton)

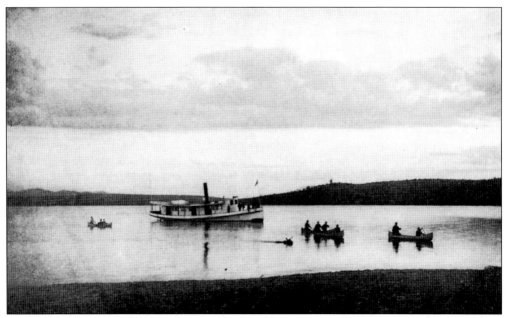

A snapshot of a moose hunt in front of the Mount Kineo Hotel, 1880s. This photograph was featured in the 1901 Mount Kineo Hotel brochure, and was taken by Thomas Sedgewick Steele, Hartford, Connecticut. (G.D. Hamilton)

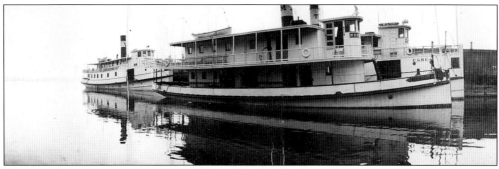

The *Katahdin*, *Moosehead*, and *Twilight* of the Coburn Steamboat Company fleet at the Greenville Junction Dock, c. 1915. Leon Greely wrote "the boat I fired last summer" on the back of the photograph.

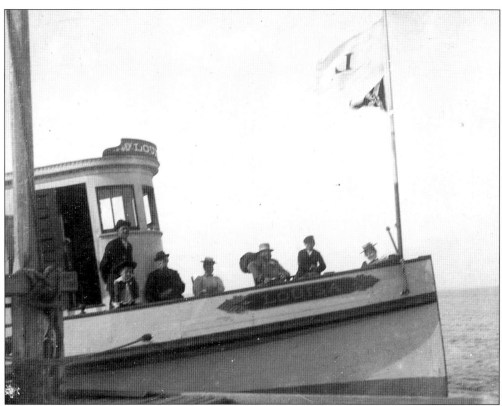

The steamboat *Louisa* of the Coburn fleet, 1890s. Sam Cole, his wife, and friends are on deck. The boat is tied to the dock at Wilson's Hotel, East Outlet.

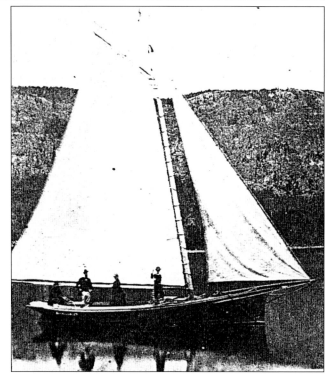

A sailboat in front of Mount Kineo, 1870s. This photograph was taken by S.S. Vose, of Skowhegan, Maine, and sold as a stereo view card. (MHPC)

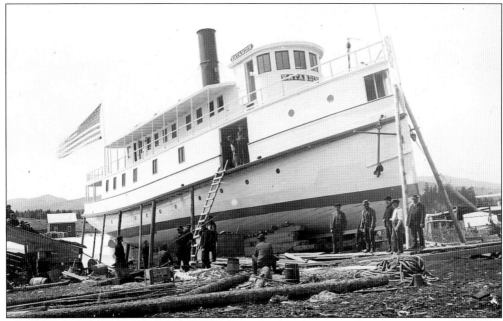

The original *Katahdin* steamboat hauled out on the lake shore, 1900s. The crew is standing in the door and at the bow. (H.A. Sanders Jr.)

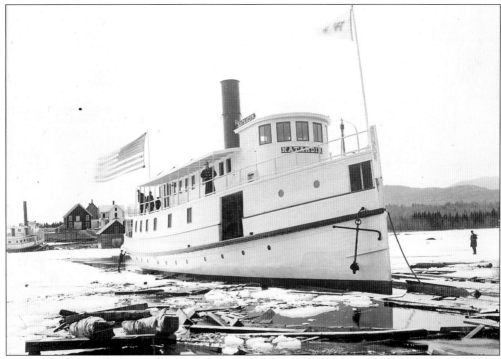

The original *Katahdin* steamboat in the lake with ice, 1900s. Both of these photographs were taken by Paul Johnson of Brownville. (H.A. Sanders Jr.)

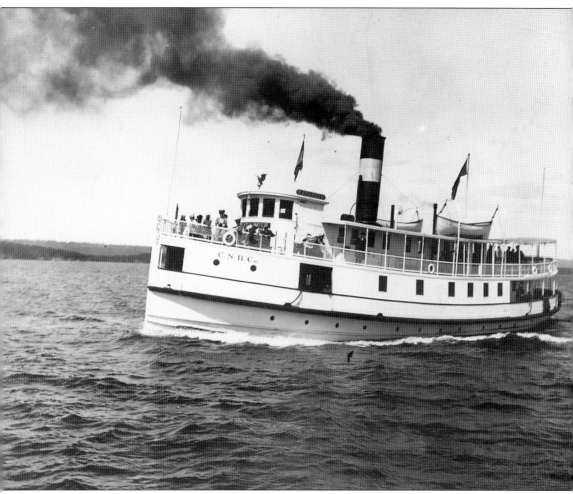

The steamboat *Katahdin* headed south on Moosehead Lake, 1900s. This is the original wooden hull boat built in 1896 by the Coburn Steamboat Company. The boat caught fire near Sand Bar Island on May 13, 1913, while towing south on the lake. The boat, navigated by Captain Robinson, ran aground near East Outlet and burned to the waterline. The new *Katahdin* (featuring a steel hull from Bath Iron Works) was built in the winter of 1914. The hull arrived by railroad to Greenville Junction and it was assembled at the Coburn Steamboat yard. Walter MacDougall noted, "She was registered for 500 passengers, and her upright boiler was the largest in Maine." It is interesting to note that 500 is the same number of people that the Kineo House could accommodate. The new *Katahdin* or "Kate" is a 116-feet boat that weighs 250 tons and has been the focus of restoration beginning in 1979. The "Kate" was converted to diesel power in the 1920s and prospered until the Depression and the expansion of local roads. In 1938, the Coburn Steamboat Company sold out to Great Northern Paper Company; the "Kate" is the last remaining boat. (G.D. Hamilton)

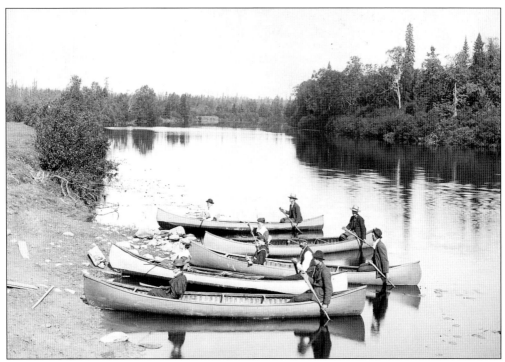

A portage party on the shore of the Upper West Branch of the Penobscot River. The party includes Fred and Charles Wilson, George Masterman, Hiram Coombs, Roy Nelson, and their wives or guests. This pair of photographs were taken by E.R. Starbuck of Brunswick, Maine, as part of the *Woods of Maine* series. (G.D. Hamilton)

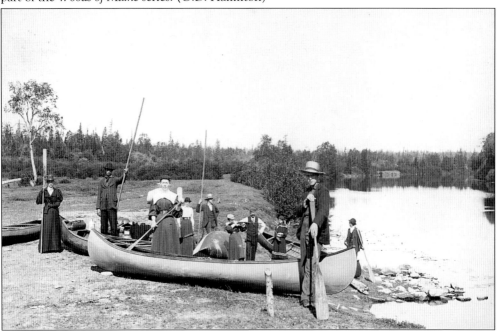

A portage for five parties in canoes on the Upper West Branch of the Penobscot, Northeast Carry to West Branch site, 1890s. (G.D. Hamilton)

Four
The Center of the Lake: Mount Kineo and the Buildings

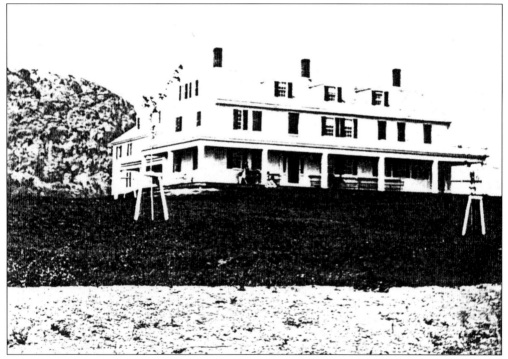

The earliest known photograph of Captain Joshua Fogg's original 1848 Mount Kineo House, 1860s. Newly planted trees are featured in later engravings. (MHPC)

Possibly the most well-known landmarks of the Moosehead Lake Region are Mount Kineo and the other hotels of the past. The mountain named Mount Kineo is composed of blue-green rhyolite shaped from glaciers moving across the land. This stone was used by native peoples who arrived here some 11,000 years ago. Native peoples lived on the Kineo peninsula intermittently before and during the arrival of Euroamericans in the seventeenth century. Mr. Hilderth was the first to build a permanent structure in 1844.

The scale of the hotel increased and peaked between 1910 and the 1930s with accommodations for five hundred people. At one time the Kineo House was the largest inland water hotel in America. The following images capture some of the changes.

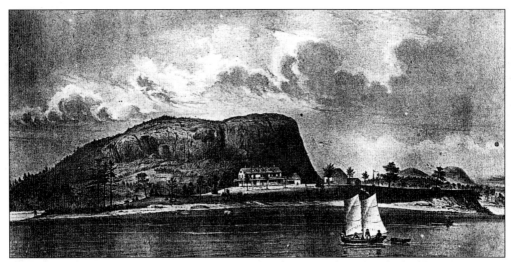

A photograph of an 1844 Kineo House engraving. Captain Joshua Fogg built the Mount Kineo House for use by lumbermen, hunters, and river drivers. The Kineo House was built as an expansion of the Hildreth Brother's Tavern. (MHPC)

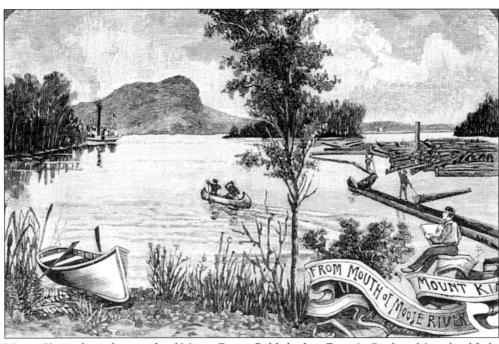

Mount Kineo from the mouth of Moose River. Published in *Farrar's Guide to Moosehead Lake and the North Maine Wilderness* (1890).

A camping party in birch bark canoes at the Mount Kineo House, 1872. The start for upper Moose River in September. This photograph was featured as a stereo view card. (MHPC)

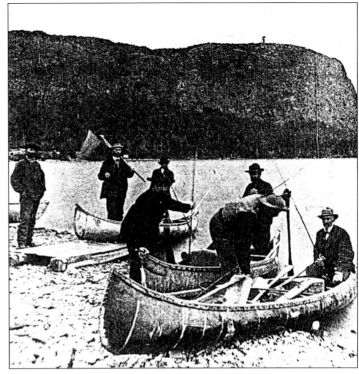

Old Sabattis at Kineo, 1870s. This photograph is from J.P. Armbrust's series of stereoscopic views of Moosehead Lake and the vicinity. It is #22 in the series of 28. (G.D. Hamilton)

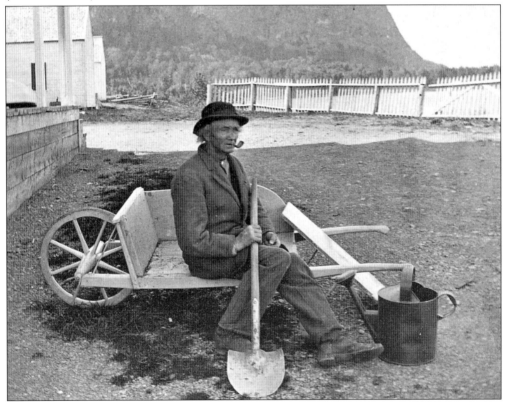

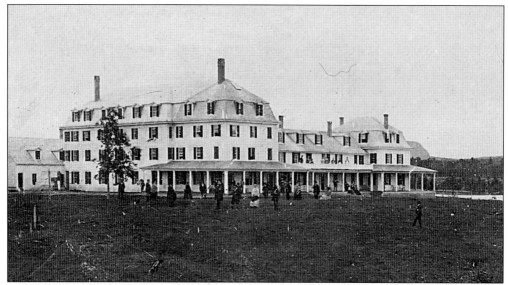

The second Kineo Hotel from Trout Point on Moosehead Lake, 1870s. Over twenty-five people are standing on the porch of the hotel. Two people are sitting on the beach in the foreground. This hotel was built in 1871, and burned in 1882. The photograph by C. and G.H. Drew, Boston, was #21 in a series of stereoscopic views. (G.D. Hamilton)

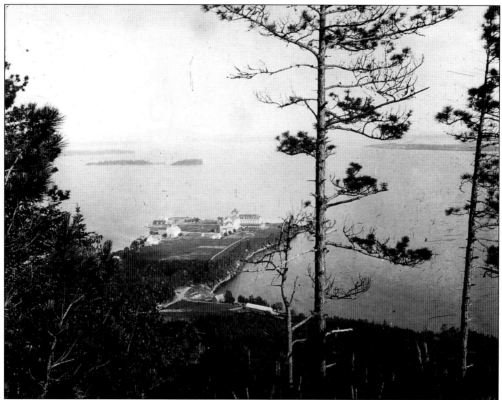

A panorama of the Kineo peninsula and the fourth Kineo Hotel from the Chain Trail up Mount Kineo, 1892. The islands beyond the hotel are the Moody Islands.

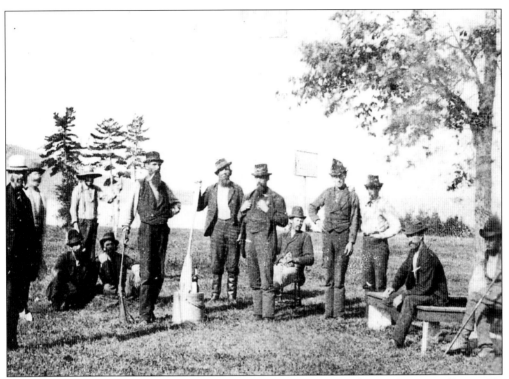

Old time guides at Kineo. According to H.A. Sanders, "Jason Hamilton is the very tall man. He was Bernice Canders Great Grandfather." The faces remain but many of the names are gone. (H.A. Sanders Jr.)

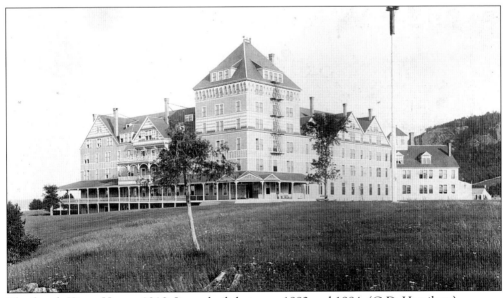

The fourth Kineo House, 1910. It was built between 1882 and 1884. (G.D. Hamilton)

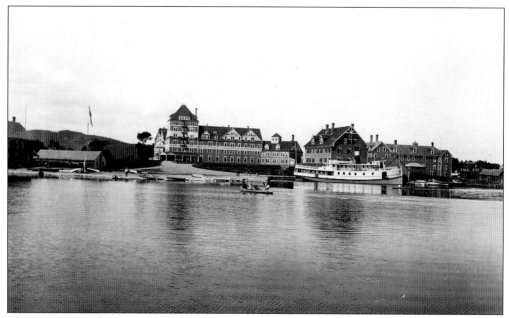

The Mount Kineo House, 1890s. This view shows the wharf area at the hotel and the corner of the old Guide House at the left.

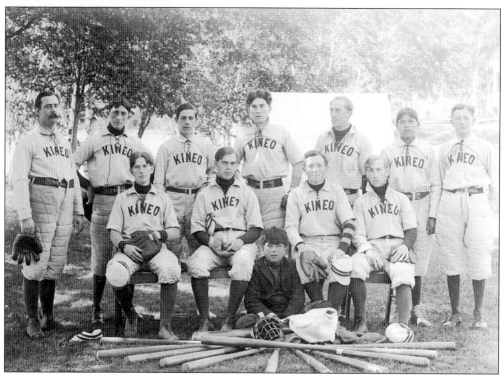

The Kineo baseball team at Mount Kineo, 1930s. The members, who also worked in the hotel, played against such teams as Greenville, Guilford, Corinna, Abbott, and Camp Allagash. The Kineo team and others included several Native Americans players as can be seen in this photograph. (G.D. Hamilton)

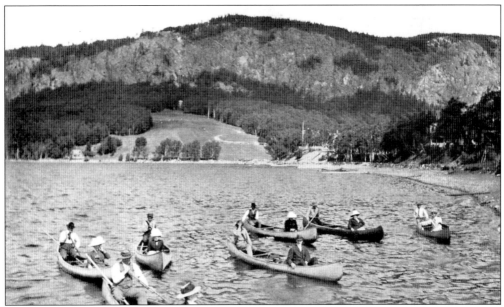

A party of canoeists near the Mount Kineo House, 1915. People were encouraged to use the "primitive" canoe. (G.D. Hamilton)

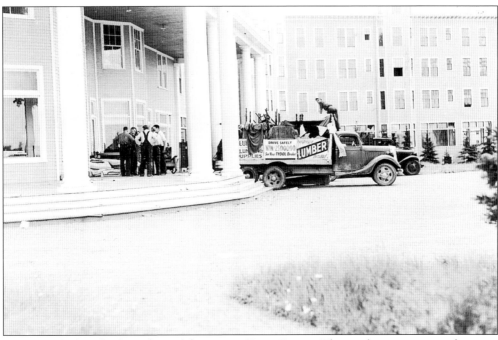

Trucks backed to the front door of the Mount Kineo Resort. The trucks are removing furniture and hardwood molding prior to the tearing down of the structure in 1938. (H.A. Sanders Jr.)

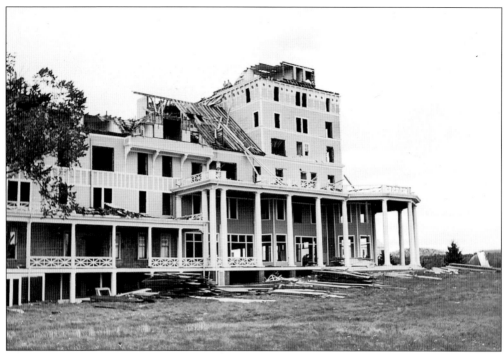

The top of the Mount Kineo Hotel, with the tower and roof removed. The Maine Central Railroad sold the hotel slated for demolition. (H.A. Sanders Jr.)

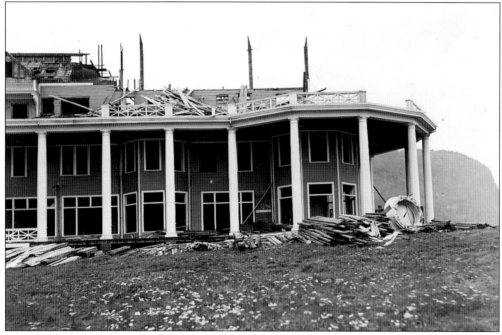

The Kineo House down, 1938. This photograph was mailed to Mr. Harry Sanders Jr., and reads "Kineo House as seen Sept. 23, 1938." The card is postmarked Ogontz, Maine. In revitalizing the hotel the "Colonial style" was added; this photograph represents the end of the Colonial period at Kineo.(H.A. Sanders Jr.)

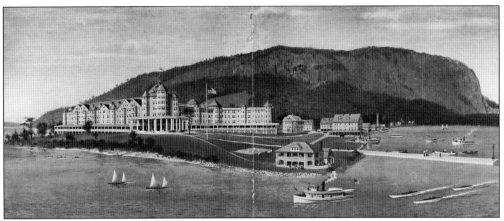

A view from Moosehead Lake of the new Mount Kineo House, the yacht club house and surrounding buildings, and the wharves, beaches, golf links, and woods nearby.

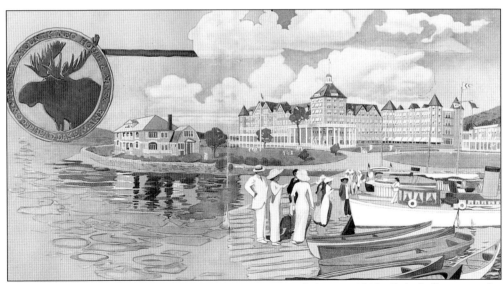

An advertisement for the new Mount Kineo House and Annex, 1913. C.A. Judkins was the manager, and it was managed at this time by the Ricker Hotel Company, Portland, Maine. The hotel business was now in its sixty-ninth year. Accommodations had increased to five hundred guests.

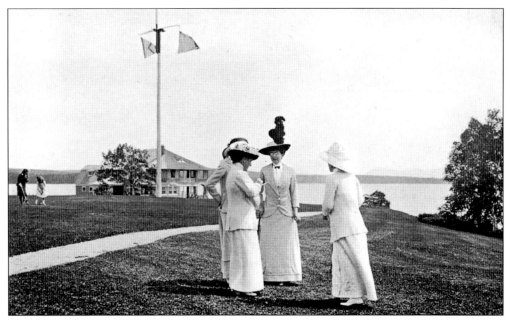
Women visiting on the lawn of the new Mount Kineo House, 1915. (G.D. Hamilton)

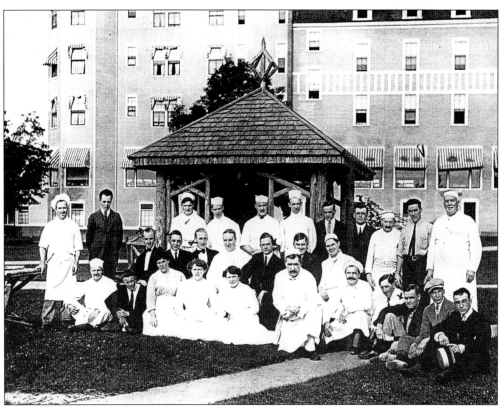
Cooks and dining room help at the Mount Kineo Hotel, 1914–15. (MHPC)

Consomme Vermicelli Clam Chowder

 Baked Fresh Codfish au Gratin
 Lettuce Olives Cucumbers

 Boiled Ham, Champagne Sauce

Roast Sirloin of Beef, Dish Gravy
 Roast Stuffed Vermont Turkey, Cranberry Sauce
 Roast Spring Lamb, Mint Sauce

Fillet of Beef aux Champignons
 Chicken Fricassee with Flageolets
 Compote of White Heart Cherries, Sauce au Sabayon

 Cold Boiled Tongue Cold Roast Lamb

Boiled Potatoes Green Corn Squash Peas Mashed Potatoes
String Beans Spinach Boiled Sweet Potatoes Beets

 Baked Rice Pudding, Cream Sauce
Apple Pie Cocoanut Pie Blueberry Pie
 Brandy Jelly Banana Souffle Pineapple Slices
 Almond Jelly Cake Sponge Drops Whipped Cream
 Assorted Cake
 Orange Ice Cream

 American Cheese Edam Cheese Boston Crackers Graham Wafers
 Watermelon Blackberries Bananas Thin Water Biscuit
 Assorted Nuts COFFEE TEA London Layer Raisins

MT. KINEO HOUSE,
 KINEO, MAINE. Tuesday, Sept. 9th, 1890.
 Meals served in rooms charged extra.

The dinner menu at the Mount Kineo House, Kineo, Maine. The menu is for Tuesday, September 9, 1890. (G.D. Hamilton)

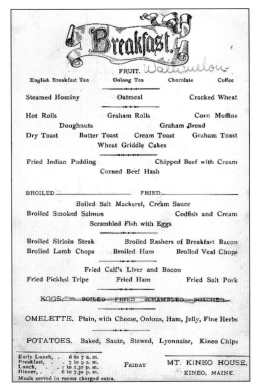

The breakfast menu at the Mount Kineo House, Kineo, Maine. The menu is for a Friday in 1890. (G.D. Hamilton)

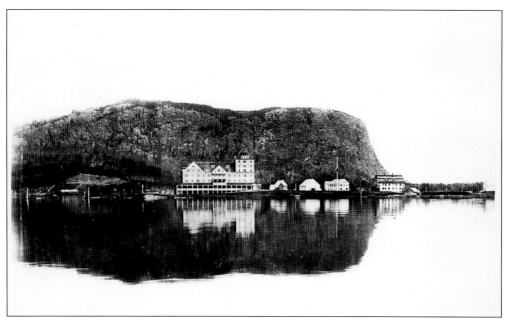

The Mount Kineo House, 1890s. The house is shown in the days when the old Guide House was on the southeast point. The old Guide House was replaced by the Moosehead Lake Yacht Club. (G.D. Hamilton)

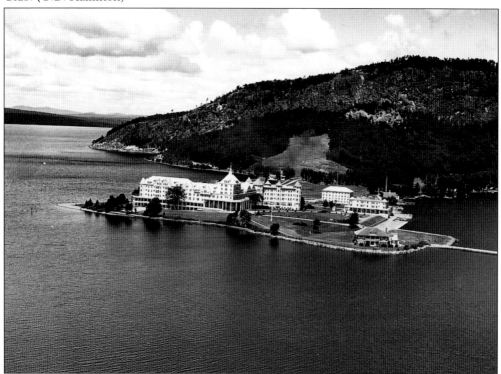

The Curtiss Wright Flying Service took this oblique air photograph of the new Mount Kineo House, 1930s. At the time of this photograph the hotel was in its final years and was under the management of the Ricker Hotel Company, Boston. (H.A. Sanders Jr.)

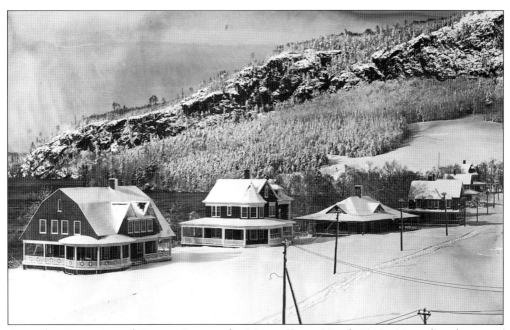
An early winter view of Cottage Row at the Mount Kineo Hotel, 1910s. Note that the top of Kineo Mountain was cleared of trees. (G.D. Hamilton)

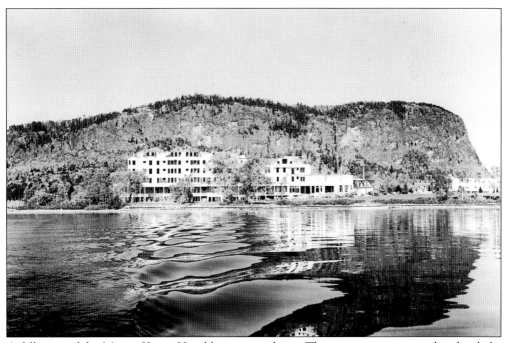
A fall view of the Mount Kineo Hotel being torn down. The mountain is covered with a light layer of snow. The remainder of the hotel burned down. (H.A. Sanders Jr.)

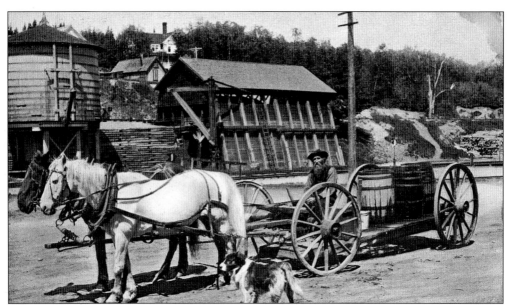

A horse team hauling a wagon with water barrels, 1910s. The team is in front of the Junction water works. The driver of the team may be Mr. Marsh.

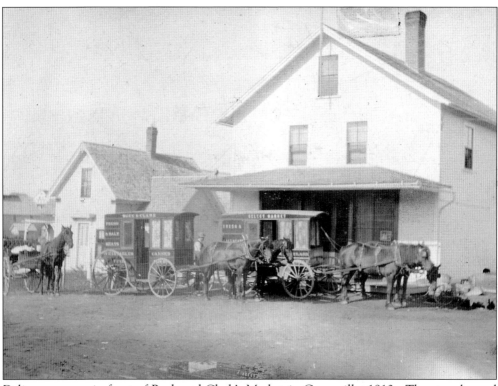

Delivery wagons in front of Buck and Clark's Market in Greenville, 1910s. The store burned down and was located between the present Fleet Bank and Morrill's Lumber Co. The wagons delivered fresh meat to area homes and hotels. In 1907, Buck and Clarke's had the largest freezer building north of Bangor, holding 25,000 pounds of ice. (H.A. Sanders Jr.)

Five
On the Land: Horse and Carriage, Trains, and Cars

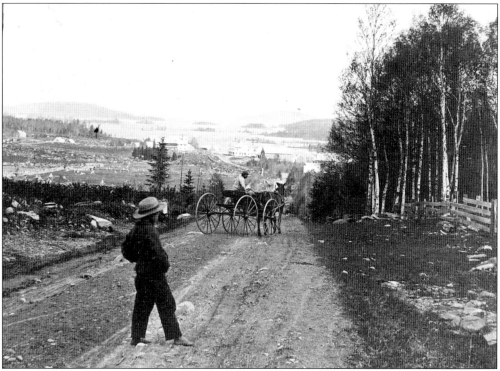

Moosehead Lake from Indian Hill, 1870s. This photograph is from J.P. Armbrust's series of stereoscopic views of Moosehead Lake and the vicinity. The Eveleth House is on the newly cleared land at the foot of the lake. A McDonald's restaurant was constructed near the area of the birch trees in 1994. The photograph is #1 in a series of 28. (G.D. Hamilton)

Changes in transportation from the horse and carriage to the train and later the car have greatly affected how people used the land. The oxen and horse opened up the initial exploitation of the land and continued into the era of machines. The arrival of trains, including the Bangor and Piscataquis, with the Bangor and Aroostook, the Canadian Pacific, and the Somerset Railroad following soon after, greatly expanded tourist activities and the need for new paths. Some of the well-worn paths and equipment needed to get there are featured here.

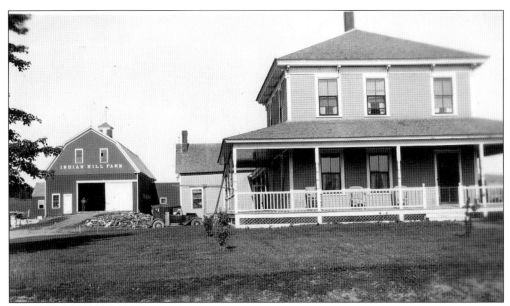

The Indian Hill Diary Farm, 1930s. The dairy, owned and operated by the Muzzy family, was an important part of the local economy.

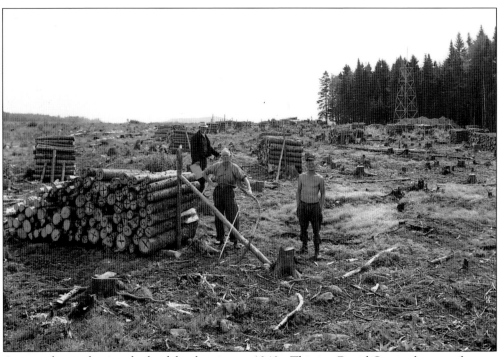

A crew of men clearing the land for the airport, 1940s. This is a David Curtis photograph.

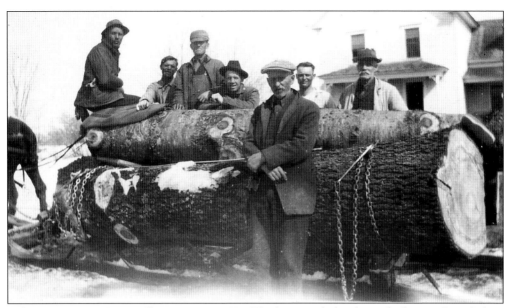

A logging crew at Greenville Junction, 1900s. The logging sled is drawn by horses. Sam Cole is standing in front of the white building. (G.D. Hamilton)

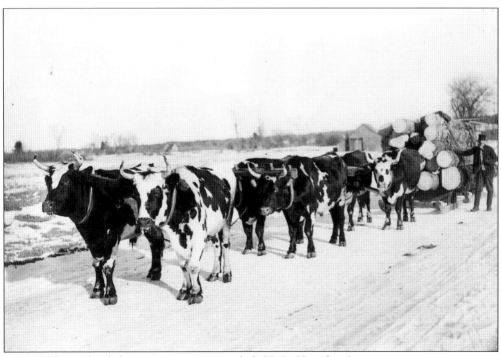

A team of oxen hauls logs on a winter snow sled. (G.D. Hamilton)

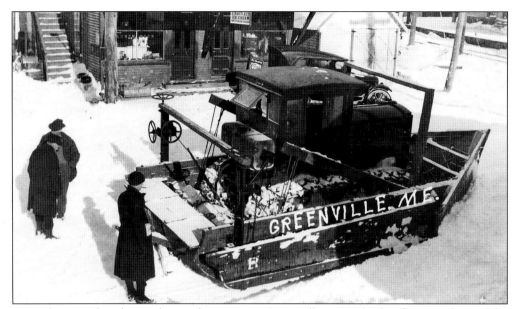

An early snow plow designed around a tractor in Greenville, c. 1925. The plow is in front of the Bartlett Ice Cream Store at the village. (G.D. Hamilton)

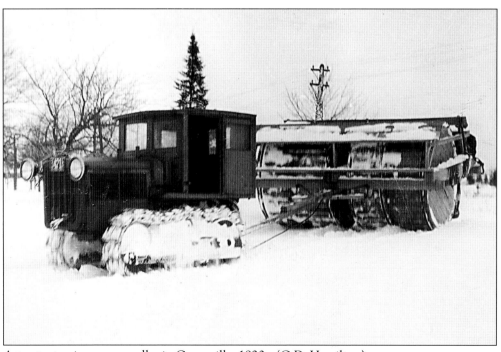

A tractor towing a snow roller in Greenville, 1920s. (G.D. Hamilton)

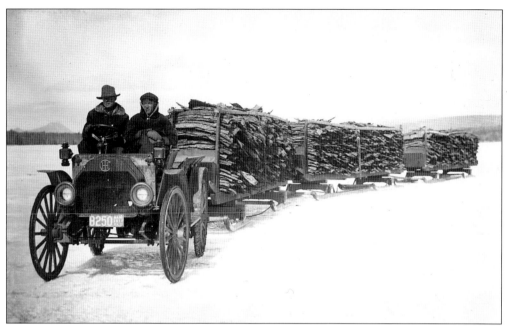

An automobile hauls three sleds of laths on frozen Moosehead Lake, 1910s. The year on the license plate is 1915, and the automobile is among the first in Greenville.

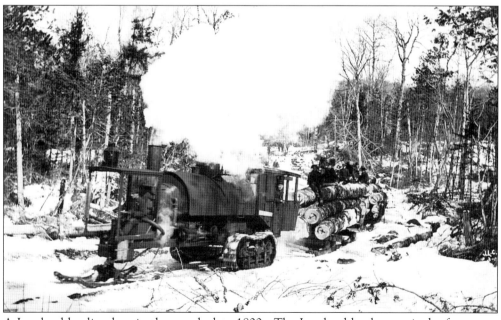

A Lombard hauling logs in the woods, late 1800s. The Lombard hauler required a front man to steer, and a rear driver to fire the engine. The crew is riding on the logs being hauled. (H.A. Sanders Jr.)

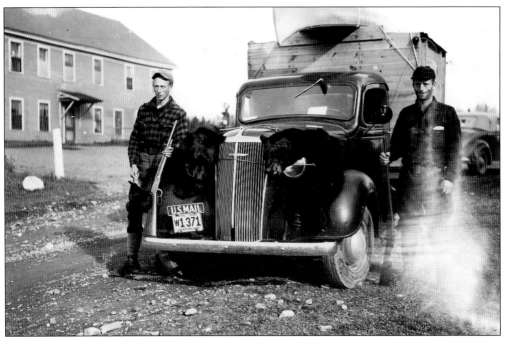

Two black bears tied onto the hood of the U.S. Mail car in Greenville, 1938. (G.D. Hamilton).

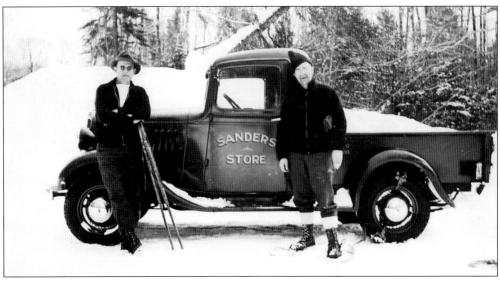

Harry Sanders Jr. and friend on a winter snowshoe trip with the Sanders Store truck, 1940s. (H.A. Sanders Jr.)

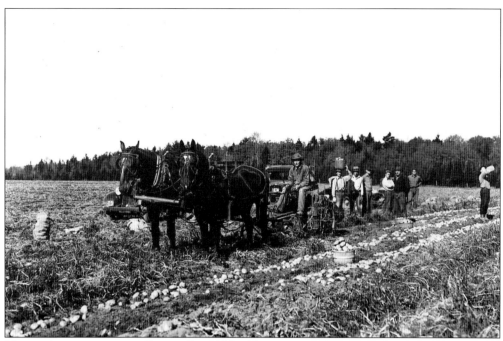

Men picking potatoes in Greenville, 1920s. Two cars can be seen behind the horse-drawn plows. (G.D. Hamilton)

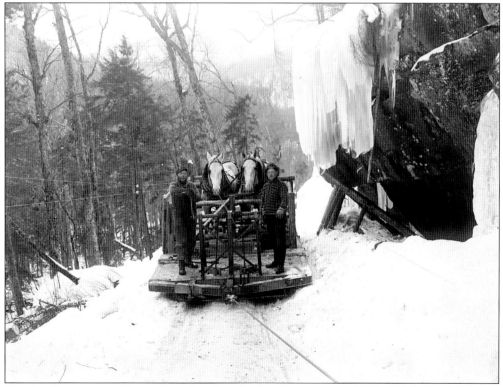

Men hauling a team of horses by railroad tracks during the winter, 1900s. (H.A. Sanders Jr.)

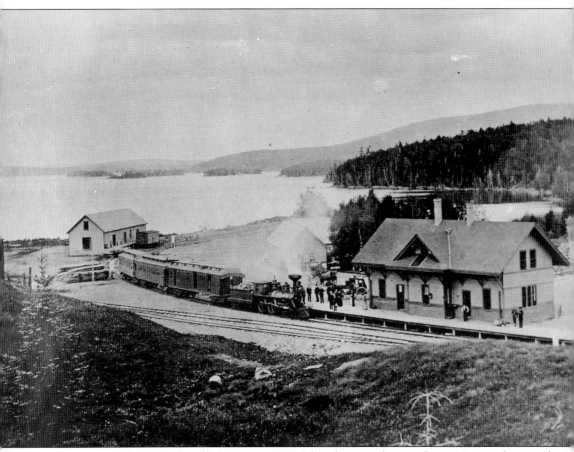

The train station at Greenville Junction, 1888. This photograph was taken on September 8 and features Engine #3 with three flat cars of the Bangor and Piscataquis Railroad. At the right is a view of the old Junction bridge over Outlet Brook. On the left end of the station is a stage coach of the Hunting and Morrison Line. The building at left is the train shop, later enlarged and used to store equipment and automobiles. This photograph was taken prior to the construction of the Canadian and Pacific Railroad line, 1887–89. The CPRR line and trestle cross would cut across this photograph. According to H.A. Sanders Sr., the CPRR was finished in 1888 and took about two years to build. The contractors were William McKenzie and Dan Mann, and the subcontractors were Starrs and Asquith, John Sunstrum, Dailey, and Cavanaugh (treasurer). All the land in the foreground was subsequently leveled for additional tracks, and most recently it has been the site of Breton's second store. Harry at the age of twenty-nine bought a beaver coat from Cavanaugh for $100. Pat Burns sold beef to contractors and later became the Armour Meats of Canada, with headquarters in Toronto. Don Wilson indicated that the granite used for bridges up the west side of the lake was quarried from the top of Moose Island.

A map of the Bangor and Aroostook Railroad and the Canadian Pacific Railroad as they reach Moosehead Lake, from *In the Maine Woods* (1934). *In the Maine Woods* was published annually beginning in 1895 and continuing into the 1950s. This publication was one of the best guide books to northern Maine and contained numerous stories of the Moosehead Lake region.

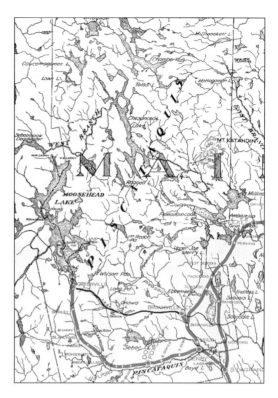

The Bangor and Aroostook Railroad Company schedule for the summer of 1932.

101

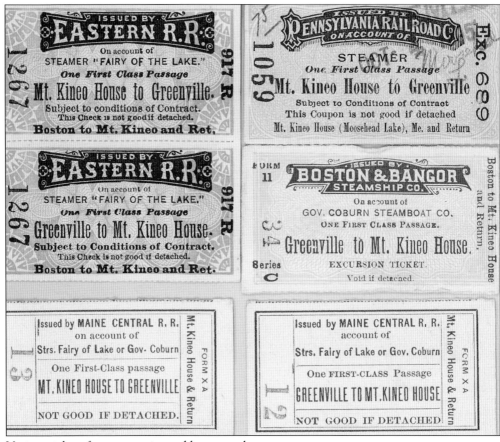

Various tickets for stage, train, and boat travel.

Two ends of a cottage living room, 1920s. These are David Curtis photographs. Note the beautiful baskets and Navajo rugs.

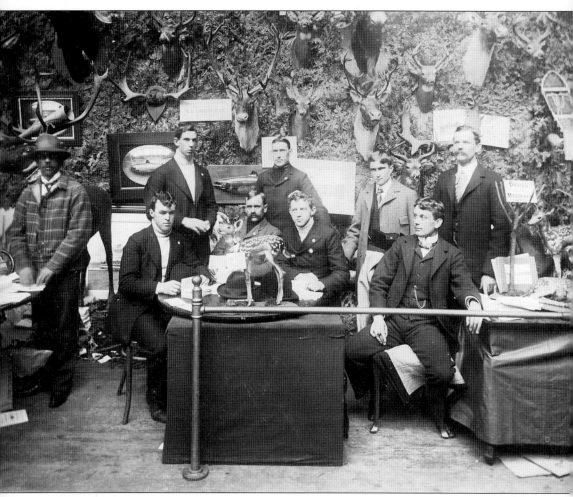

Moosehead lake businessmen at the New York Sportsman show, *c.* 1905. This photograph is of special interest in the promotion of the west side of Moosehead Lake. From left to right are: (seated) Alfred James Wilson, Hiram Coombs, Charles Edward Wilson, and Carl Sawyer; (standing) Ed Harlow, George Masterman, Roy Nelson, ? Burdeen, and Mike Marr. This photograph was originally on display at Wilson's Hotel and was labeled by them. Fred and Charles were sons of Henry I. Wilson who in 1865 started the Tavern and later Wilson's Hotel at East Outlet. Charles took over management of the hotel from his father and Fred followed until 1940 when his son Don took over. Ed Harlow and Hiram Coombs were guides. George Masterman was a cousin of the Wilsons and was born on Sandbar Island. Sandbar was part of the earliest farm on the lake, built by John Masterman, his grandfather. Roy Nelson was a guide and worked for the Wilsons; Roy's son, Charles Nelson, became superintendent of the Great Northern Paper Company. Roy was reported as being the first person to catch a "landlocked" salmon after they were introduced in Moosehead in 1879 (he was thirteen at the time). Mike Marr was owner of Marr's Camps at Indian Pond. Many of his camps were moved when in 1953 when the dam built by Kennebec Water Power Co. permanently flooded his land. This photograph features a full-sized caribou and several heads on the wall. The Maine caribou eventually became extinct, and the deer expanded in numbers within the next few years after. (G.D. Hamilton)

Six
Some of the People . . . Not All of the People

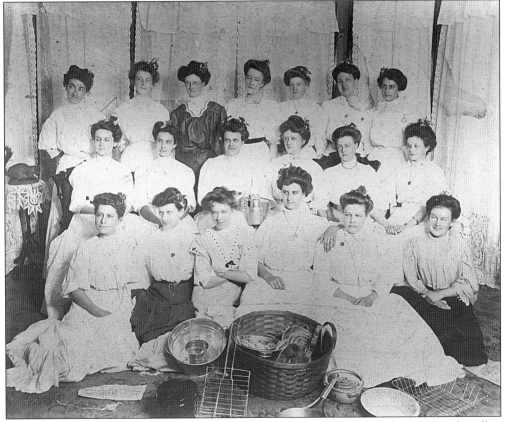

Women who worked at the sporting camps, 1900s. This photograph was displayed in the office of Marr's Camps.

By the 1870s and 1880s, there were some five to eight hundred people living in the region. The numbers reflect a strong old core of settlers from the nineteenth century. Many people have created the regional character, and some of them are featured here.

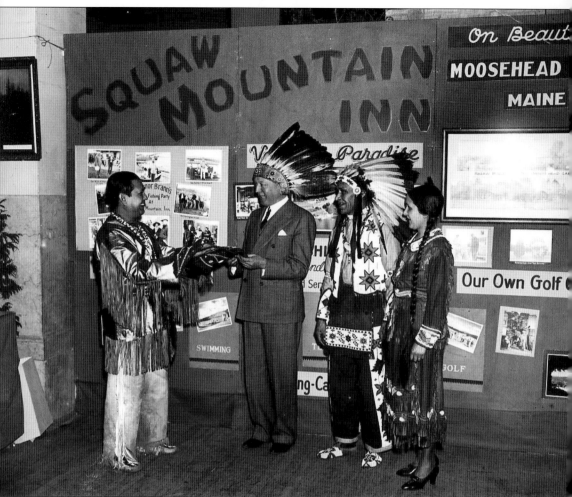

According to H.A. Sanders, this photograph is "Courtesy of the State of Maine Fish and Game Commission. Sportsmen Show at Grand Central, photo shows: Nee-dah-ben, Maine Wenousoot indian and Master of Ceremonies of the show at the exhibit of the State of Maine presents a wampum of welcome to Governor Louis Brann of Maine. Looking on are Henry Red Eagle Perley of Moosehead Lake (third from left) and Princess Lone Cloud of Moosehead Lake on right." (March 7, 1936). This photograph with a dated and typed caption was given to Jerry Hamilton by Henry. Of interest, the advertising features a fishing trip by Maine Governor Brann to the Squaw Mountain Inn. At this time he proposed the million acre "Roosevelt Park" for the woods of northern Maine.

Henry Red Eagle Perley and Harry Rollins in front of the Moosehead Lake display at the Boston Sportsman's show. Henry promoted the "romantic" aspect of a Moosehead Lake in the region. Henry was an Algonquin. (H.A. Sanders Jr.)

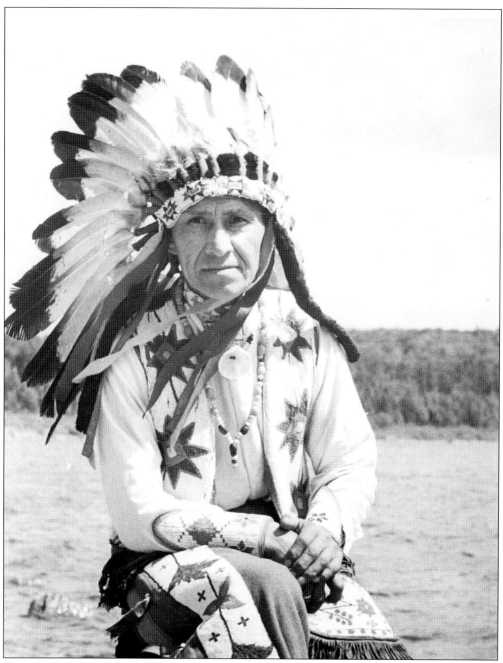

Henry Red Eagle wearing headdress and beadwork at Moosehead Lake. When asked his age, he would reply "I came here when I was 18 and have been here ever since," or "I came here when Squaw Mountain was this small (with his hand a foot off the ground)." Henry and his wife Wanna Eagle had a set of camps on Sugar Island. Wanna helped polio victims and many other people with summer recreation. After Wanna passed away she was buried on the island near her two dogs. This photograph was taken by Garret S. Hobart. (H.A. Sanders Jr.)

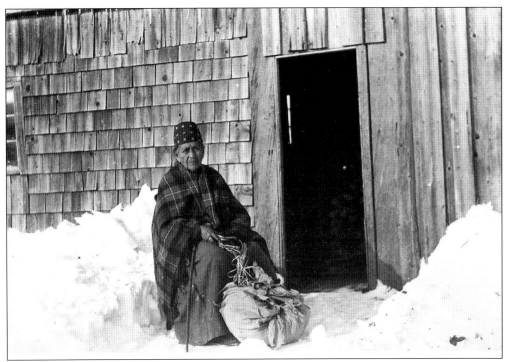

Mary Newell-Tomah from Churchill Lake. She was the wife of Francis Xavier Tomah, and the mother of Philomen, who was married Gabriel Frank Perley (and known as "Gabe"). Mary's children were born at Kineo in the 1840s and '50s, and she is Chief Henry Red Eagle's grandmother and Madalene Burnham's great grandmother. She lived to be over ninety years old and was killed in a fire at Chesuncook, where she is buried. In the 1960s H.A. Sanders Jr. indicated that her home, pictured here, was where the road used to cross the land of Elmer McFadyen. (H.A. Sanders Jr.)

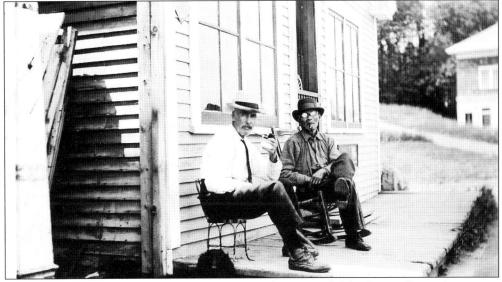

John Hall (left) and Oliver Bernard sitting on the steps of Zelie Bernard's candy store in Greenville, 1919.

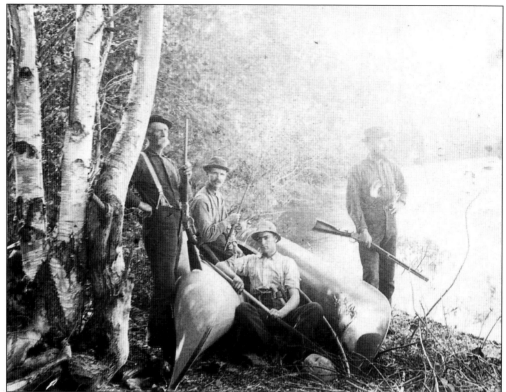

Four men with rifles and canoes, July 1892. From left to right are Samuel Cole, Albert Leach, Waldo Plimpton, and Harry Burrage at the "W" Farm, Moosehead Lake. The photograph was labeled by Sam Cole.

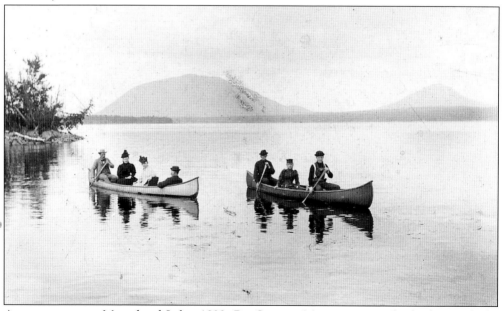

A canoe party on Moosehead Lake, 1892. Big Spencer Mountain is in the background; the photograph was probably taken from Deer Island.

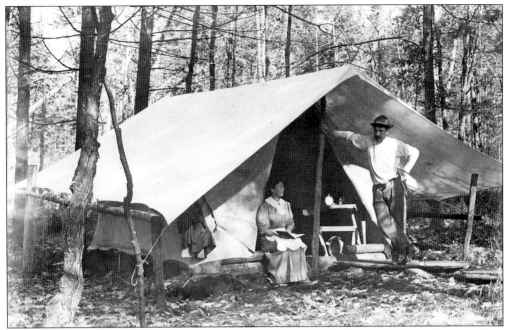
Summer tenting at the turn of the century, c. 1915. This scene depicts a summer homestead in the Moose River drainage, west of Moosehead Lake.

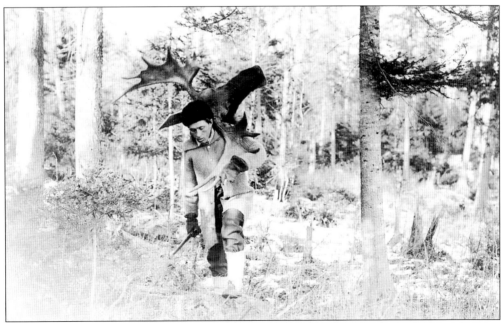
A hunter of the McKinney family carrying a moose head out of the woods, during an autumn in the early 1910s. In 1912 or so there was a decline in the number of moose from hunting and the taking of trophy heads. The taxidermist business had a significant influence on resources.

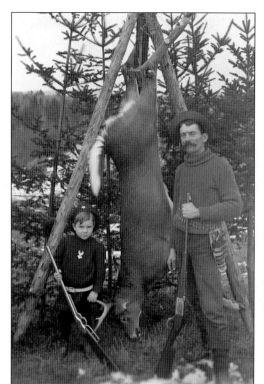 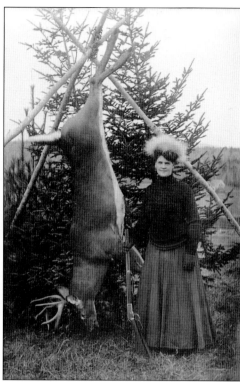

Left: A man with a rifle and a boy with a toy rifle pose near a six-point buck, Moosehead Lake Region, 1900s. (G.D. Hamilton)

Right: A woman with a Winchester rifle and a ten-point buck, Moosehead Lake Region, 1900s. (G.D. Hamilton)

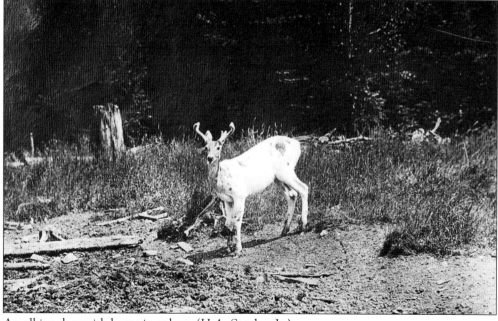

An albino deer with horns in velvet. (H.A. Sanders Jr.)

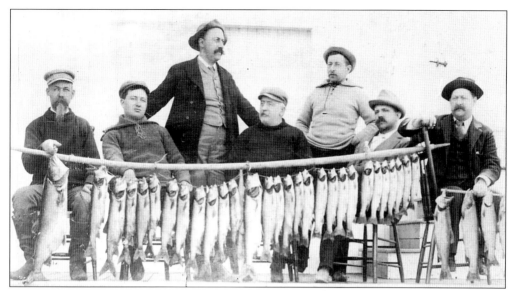

A fishing party of the Camp Comfort Club at Moosehead Lake, 1896. A statistical fishing log was maintained from 1894 to 1953; it is an important historical record for the lake, and was researched by Roger AuClair. (H.A. Sanders Jr.)

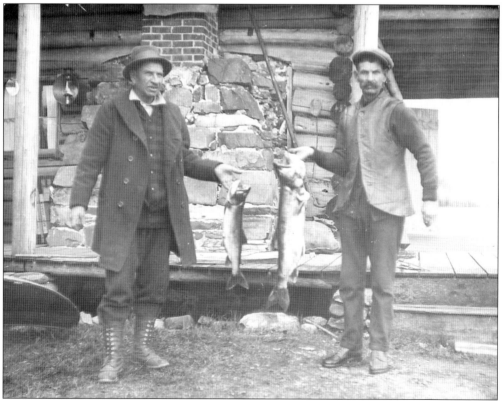

Two men with togue (lakers) caught in Moosehead Lake, 1910s. The largest togue caught in America was a 32-pounder taken in Moosehead, displayed for many years at Sanders Store. (H.A. Sanders Jr.)

Mr. Milton Gilman Shaw, c. 1880s. Milton G. Shaw arrived in Greenville in the fall of 1845, and established a pine and spruce logging and timber selling business at the foot of Moosehead Lake. In 1871, Shaw established the Shaw Mill in Bath, Maine, to process the logs into a multitude of products, including boards, clapboards, shingles, and laths. In one log drive on the lake, his company sent 8 million board-feet of long logs down the Kennebec River. Shaw was a significant leader in Greenville and established the steamboat companies and bank. This portrait was by Holmes of Bath, Maine. (H.A. Sanders Jr.)

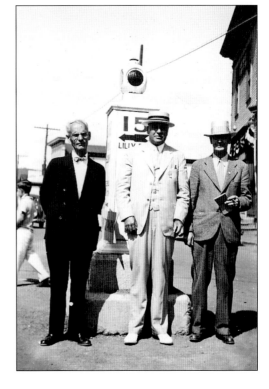

From left to right are Louis Oakes, William Shaw, and Jay Brown, c. 1930s. Louis Oakes was a surveyor and was very interested in forestry. He worked for the H.&W. Co. which later became Scott Paper Co. His wealth came from grubstaking his brother Sir Harry Oakes on a mining operation in Canada. He built the high school for Greenville and was a philanthropist. In 1940 Oakes purchased Kineo, which was managed by his grandson Louis Hilton in the 1950s and '60s. The sign post to the rear was situated in the center of the street, parallel with the Shaw Block. (G.D. Hamilton).

Mr. David Thomas Sanders, c. 1890, by Weston Studios of Bangor. David T. Sanders was born in 1836, and died in 1910. His father was Thomas A. Sanders, who is buried in the Guilford cemetery. Thomas Sanders immigrated to Maine from Greenwich, England, in 1812 when he was twelve years old. David Sanders apprenticed with John Hildreth from age sixteen to twenty-one. He then worked for Milton G. Shaw, and in a few years established his own business. He was first married to Louisa Sawyer, who passed away at a young age, and three years later wed Celestia Robinson. His son Harry A. Sanders carried on the family business. (H.A. Sanders Jr.)

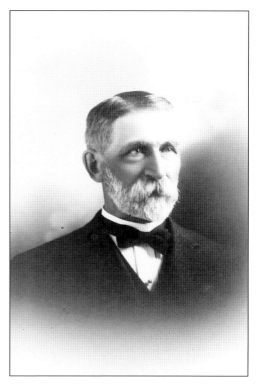

Harry Sanders at age twenty-eight, 1870s. Harry was in business at the age of thirteen with Major Strickland of Bangor. He worked in a small shack just beyond the Shaw Homestead. His father was David T. and mother Louisa Sawyer. Harry Sanders came to the firm in 1878, and the name was changed to D.T. Sanders and Son. He married Octavia Dean, and had five children; Louise, Paul, and Harry Jr. worked in the family business. (H.A. Sanders Jr.)

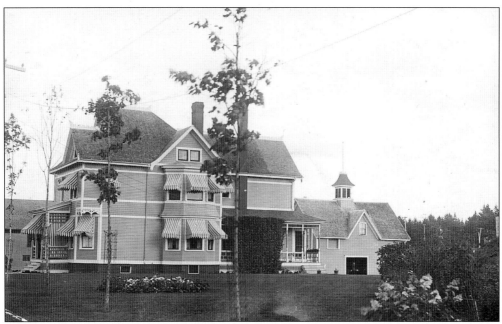

Arthur A. Crafts' residence at Greenville Junction, 1919. This photograph was sent to Miss Julia Crafts in Providence, Rhode Island, by her mother Mrs. Rebecca Eveleth Crafts. The windows have summer awnings and the trees in front are young. This photograph was taken prior to the construction of the wrap-around porch. In the early 1970s, Mrs. Julia Crafts-Sheridan willed the home to the Moosehead Historical Society, and the building is currently under restoration by this organization. (G.D. Hamilton)

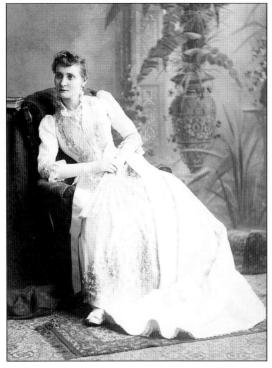

Mrs. Rebecca Eveleth Crafts, about 1895, taken at Hartley Studios, Chicago. The daughter of Mr. John H. Eveleth, manager of an inn and store in Greenville, she married Mr. Arthur Crafts, store manager, at Greenville Junction. Her original residence is now the Moosehead Historical Society headquarters. (H.A. Sanders Jr.)

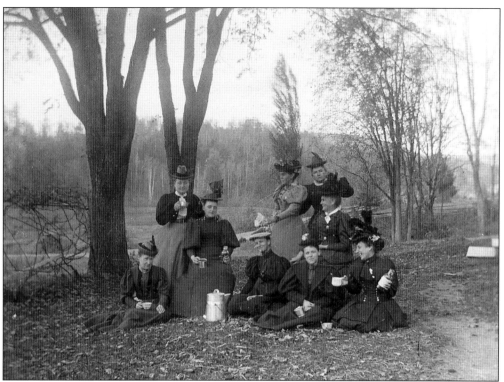

Greenville women on a picnic, c. 1890s. (H.A. Sanders Jr.)

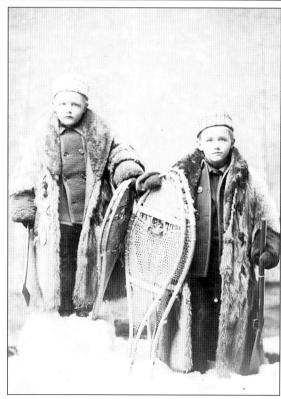

Harry A. and Paul B. Sanders of Greenville, Maine, c. 1890. This staged photograph depicts an outdoor scene with winter attire and snowshoes. (H.A. Sanders Jr.)

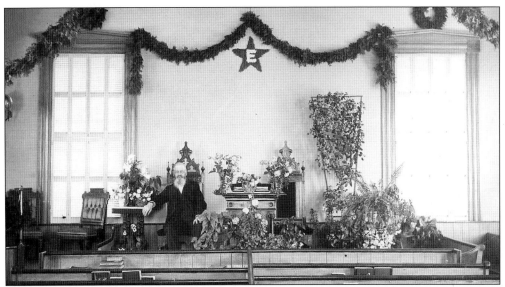

Easter decorations in the "Old Church" with Pastor Charles Davison, late 1800s. Charles Davison was originally a member of the Congregational Church of Monson, Maine, and arrived at his Greenville position about five years after the organization of the Union Church. In 1880, Loring comments that "This frontier church occupies an important position. It leads all others, considering its numbers, in its benevolent contributions." In 1880 the congregation had forty-six members. The church was a member of the Piscataquis Congregational Conference. (H.A. Sanders Jr.)

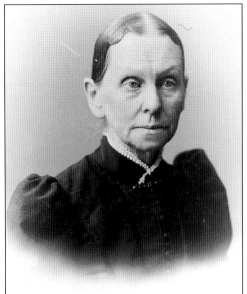
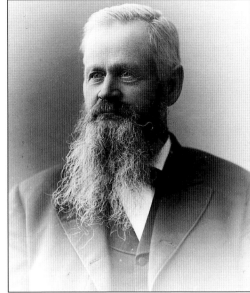

Left: Mrs. Laura T. Davison, in a photograph taken by A.H. Dinsmore in the late 1800s. Mrs. Davison organized the Missionary Society in 1874. (H.A. Sanders Jr.)
Right: Reverend Charles Davison of the Union Church, in a photograph taken by A.H. Dinsmore in the late 1800s. Reverend Davidson provided one of the dedications at the July 29, 1884, grand opening of the Kineo House. After numerous fires had claimed previous efforts at Kineo, the selection of Davidson seemed appropriate. (H.A. Sanders Jr.)

John Cussak, the hermit of Moose Island and a graduate of Bowdoin College, 1920s. According to H.A. Sanders, "John Cussak who owned Moose Island for many years. He was a strong swimmer who always boasted that there was not enough water in Moosehead Lake to drown him, but fate played him a cruel trick and he was drowned a the Moosehead Island Thoroughfare when his sled broke through the ice and dragged him down. When found, he had cleared one arm and shoulder, but the ice cold water apparently was too much for him." (H.A. Sanders Jr.)

An Indian guide at Marr's Camps, Indian Pond, holding a baby, c. 1900. (G.D. Hamilton)

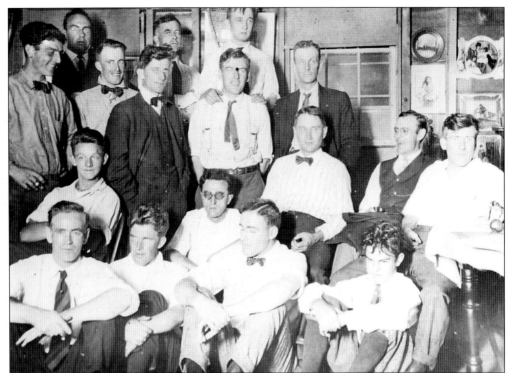

Men from Greenville, 1930s. From left to right are: (on the floor) Bung Folsom, Fred Drake, Arthur Smith, Harry Sanders Jr., and Ross St. Germain Jr.; (in chairs) Cy Porter, Will Dailey, Skip Noyes, and Ratty Smith; (second row) Dick Young, Earl Buck, Jack Galusha, Clair Savage, and Rip Young; (top row) Harold Harvey, Ross St. Germain, and Harley Budden. (H.A. Sanders Jr.)

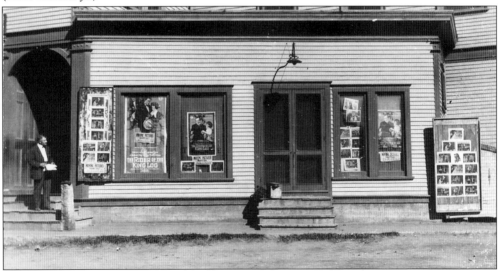

The first movie theater in Greenville was located in Shaw Block, 1920s. The theater was run by Pero Morris, and in this photograph the film being shown was *Riders of the King Log*. At this theater, Chief Henry Red Eagle received top billing over Mary Pickford in one of his films. (G.D. Hamilton)

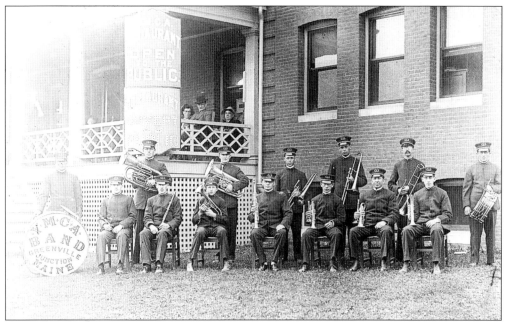

The YMCA Band in front of the YMCA in Greenville, 1920s. The sign notes both English and French. An influx of French-speaking people occurred with the opening of the Canadian Pacific Railway and the expansion of the lumber and timber operations in the area in the late nineteenth century. (G.D. Hamilton)

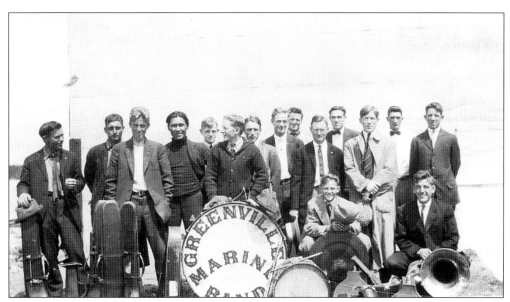

The Moosehead Marine Band, 1903. The band played as entertainment on the Coburn Steamboats. Henry Red Eagle is the fourth from the left. (H.A. Sanders Jr.)

From left to right are: (bottom) Harry A. Sanders Jr. and Edmond "Hick" Bigney; (top) Jack Johnson and Phil "Rip" Young. The original caption written by H.A. Sanders reads, "Harry, Rip and Jack had a log camp where the Murry Camp between Upper and Lower Wilson Ponds now stands. This picture was taken probably before 1915, could have been earlier—Harry, Hick and Rip were married some years later. These were wonderful years with no cares, a little money went a long way. Hick died shortly after his marriage to Ruth Young." There was an addition to the caption, written years later, which reads "This is written April 6, 1968 prior to Kate and I moving from the Ralph Brown House to the Phil Sanders (McIver) house. I am cleaning out the attic while sitting on a crate. I am 78 years next May 27 and while the memories of 49 years of snapshots and letters are sad, still Kate and I have had a wonderful life and God could not have done anymore for us than he already halt for which we are Thankful." It is signed Harry A. Sanders, Jr. (H.A. Sanders Jr.)

The Greenville Woman's Club in the 1940s. The members shown here include Violet Spinney, Marion Hamilton, Ruth Vickery, Viola Redmond, Mildred Dean, Beryl Dean, Molly Canders, Ruby Brett, and Sarah Pritham.

The school and students at Greenville, 1870s. This was among the first schools in town. This stereoscope photograph by S.S. Vose of Skowhegan, Maine, was featured in the *Moosehead Lake and Vicinity* card series. (G.D. Hamilton)

Men staying at Marr's Camps, Indian Pond, 1890s. (G.D. Hamilton)

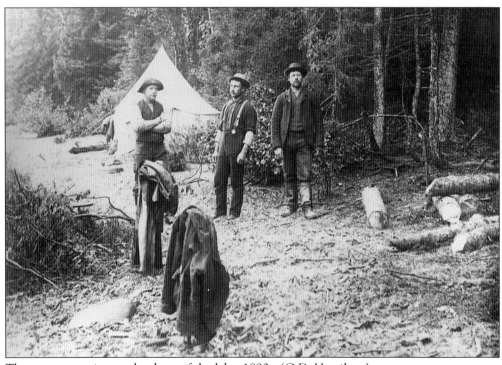

Three men camping on the shore of the lake, 1890s. (G.D. Hamilton)

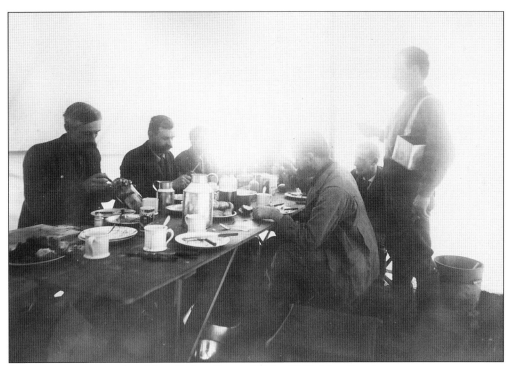
Seven men at a camp breakfast, Indian Pond, 1890s. (G.D. Hamilton)

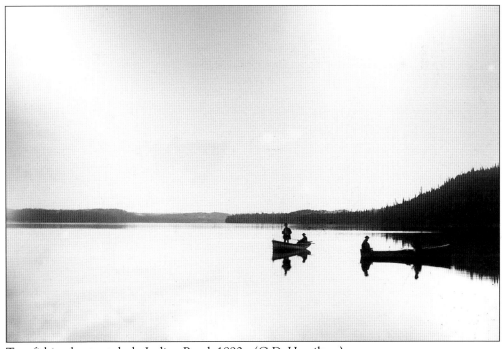
Two fishing boats at dusk, Indian Pond, 1890s. (G.D. Hamilton)

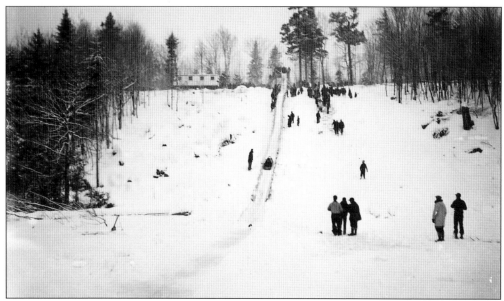

The wooden toboggan chute and ski jump at the Shadow Pond Recreation Area, Greenville Junction. The hillside was cleared and the run built in the mid-1930s by the Civilian Conservation Corp (CCC). Henry Sawyer claimed to be the first to take a jump. (H.A. Sanders Jr.)

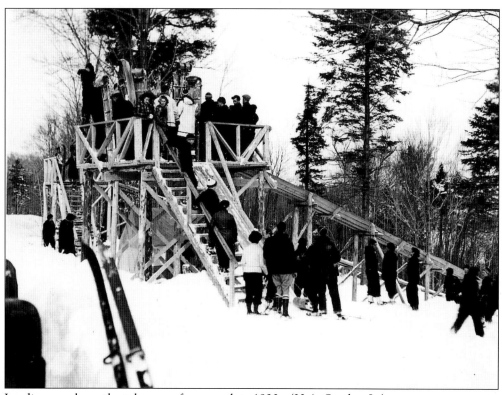

Loading people on the toboggans for a run, late 1930s. (H.A. Sanders Jr.)

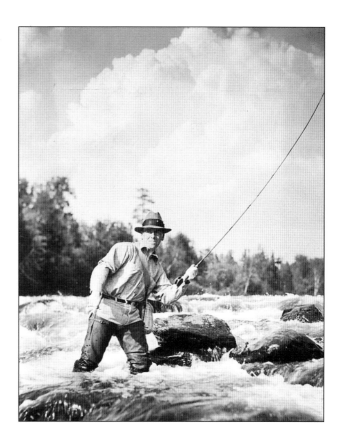

"Swirling Water" by Robert Dudley Smith, an illustrative photographer from Philadelphia. This photograph and the one on p. 128 were displayed in hotels like Wilson's and Marr's Camps. (G.D. Hamilton)

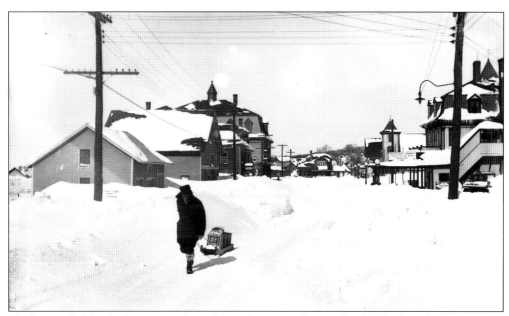

Hauling a sled load of groceries down Main Street in Greenville, 1930s. Population Density, about one per person. This is a David Curtis photograph.

"Silver Flood" by Robert Dudley Smith. (G.D. Hamilton)

Acknowledgments

This manuscript was made possible with the generous support of Gerald D. Hamilton who made available his photograph and postcard collection. He also provided ephemera, maps, and books collected over the past forty years. An equal portion of photographs in this book come from the Harry A. Sanders Jr. photograph collection entrusted to Gerald Hamilton. In 1972, just prior to passing away, Harry gave many personal and regional images to Gerald. In the collection were a sizable number that had been on display at D.T. Sanders and Sons Store. Many people who visited the store over the years may recognize some of those photographs here. Harry was very interested in documenting the past, and where possible, portions of his photo captions are incorporated with ours. This book is a tribute to Gerald and Harry, whose interest in the past is perpetuated here.

Several people and institutions have provided photographs and documents used in this compilation, and thanks are extended to: Viola Redmond; Kathryn Arsenault; Donald Wilson; Cynthia Page; Earle Shettleworth Jr., director of the Maine Historic Preservation Commission; Thomas Bennett of the Portland Room of the Portland Public Library; and Jim Bradley of the Robert S. Peabody Museum of Archaeology.

The authors would like to remember some of the people who created and maintained this interest in the prehistoric and historic period of the Moosehead Region. These include Bernice Abbott, Brud Sanders, Bernice Edwards, Elizabeth Hamilton-Hartsgrove, Burton and Irene Packard, Leona Cole, Richard Templeton, Linda Hubbard, Beau Kirstead, Wayne Champeon, Jim Petersen, Wallace and Lois Hamilton, and Robert York.

Interviews with Wallace Hamilton, Gerald Hamilton, and Donald Wilson contributed significantly to our captions.

A final word of thanks is extended to Professor Joyce Bibber of the USM History Department for encouraging this undertaking and connecting us with the publisher.

Over nine hundred images were reviewed for possible inclusion, and the two hundred selected represent a small part of the experience glimpsed here. Errors in fact are likely to be found.